IMAGES
of America

MOUNT GREENWOOD
CEMETERY

IMAGES
of America

MOUNT GREENWOOD
CEMETERY

Margaret M. Kapustiak and Paula K. Everett

ARCADIA
PUBLISHING

Published by Arcadia Publishing
Charleston, South Carolina

Printed in the United States of America

Library of Congress Control Number: 2014949976

For all general information, please contact Arcadia Publishing:
Telephone 843-853-2070
Fax 843-853-0044
E-mail sales@arcadiapublishing.com
For customer service and orders:
Toll-Free 1-888-313-2665

Visit us on the Internet at www.arcadiapublishing.com

This book is dedicated to the families of Mount Greenwood Cemetery.

CONTENTS

ACKNOWLEDGMENTS

It was an honor to recognize the "families of Mount Greenwood Cemetery," which was the working title for this book. Included within are stories of many hardworking people and families who contributed to their communities. They must have passed those traits on to their descendants, for we were overwhelmed with photographs, stories, and legends of individuals buried in Mount Greenwood Cemetery. With over 100 extra photographs, we were forced to make tough decisions about which images to include and which stories to tell. Please, if we made the wrong decision in your mind, we beg your forgiveness. We also apologize for any errors in the text. With so many submissions, names, and dates to double-check, something was bound to slip through. We tried our best.

Images and historical information in this book came from the following local history centers: the Ridge Historical Society (RHS), the Blue Island Historical Society (BIHS), the South Suburban Genealogical and Historical Society (SSGHS), the Blue Island Public Library local history division, the community records of Mount Greenwood, the Worth Park District Historical Museum, the Underwater Archeological Society of Chicago (UASC), the Oak Lawn Public Library's local history division, the South Holland Historical Society, Margaret M. Kapustiak (MMK), and the Mount Greenwood Cemetery Association (MGCA). Many thanks are owed to all.

These local universities and repositories were also very helpful: the University of Chicago Library, Special Collections Research Center (U of C); the Chicago Transit Authority (CTA); the Vincent Mercaldo Collection at the Buffalo Bill Center of the West, Cody, Wyoming (BBCW); and the Chicago Public Library, Special Collections and Preservation Division at the Harold Washington Library: CRCC1.91; CRCC1.138; and CRCC 1.559 (CPL-HW).

Finally, this book benefited from the generosity and interest of local professionals and family historians. Thank you to Linda Lane; Jennifer Kenny, architectural historian; Carol Zajac and Kim Demas, staff at Mount Greenwood Cemetery; Linda Lamberty, for many years of research donated to the cemetery; and to those who contributed information on more than just their families: Glenn DeYoung, Margaret Schroeder, Robert Swierenga, and Richard Rohloff. And—of course—many thanks are owed to our editor, Jesse Darland, for his support and suggestions. All of your help was appreciated.

INTRODUCTION

Cemeteries are open-air museums. They are not simply graveyards or havens for ghosts; they are a reflection of Americana. They are a reflection of what a neighborhood has been and what it will become. They reflect the stories and our thoughts on family, on self, and on our neighborhoods, so the hardest part of compiling this book was the need to limit the verbiage in the image captions. Many images could have been accompanied by a 200-word or more essay. We received over 100 additional photographs that have gone unused. With over 60,000 burials on 80 acres, we have done our best to be inclusive, but there are many more stories to tell.

Mount Greenwood Cemetery is an oasis, treasured by its neighbors and the families whose members reside there. Established in 1879, it reflects both the old and new and contains grave markers from three different centuries. It is a Victorian-style cemetery, with many large and decorative stone monuments set on a rolling landscape amid winding roads, with old buildings and modern landscape plantings. The nondenominational nature of this cemetery shows with Catholic crosses sharing space with statues and Methodist, Presbyterian, Dutch, and other religious symbols.

Today, joggers in colorful outfits run past a group of women who are briskly doing their morning walk while carrying cups of coffee. A sign announces a history program to be held in the upcoming weekend, while another announces an upcoming 5K race. Workers trim bushes and plant flowers. Genealogists and family historians stop in the office and then walk to memorials to the SS *Eastland*, the Iroquois Theater Fire, or the Chicago Water Crib Fire. A family honors a lost member with a ceremony in the Garden of Remembrance or at graveside, while a Civil War group places veterans grave markers. A civic group—maybe the Elks or the Masons—walks around their monument, planning their next event. A Chicago police group buys a headstone for an unmarked grave. A group of school children with its teacher examines stones and monuments. A journalist snaps a photograph. Community events and programs have always found a place here.

Entering the cemetery through the large limestone pillars and wrought iron gates, you pass into a different world. You leave the hot pavement of 111th Street and the busy commercial strips of Western and Kedzie Avenues to enter a leafy glen under oaks and tall trees. A limestone chapel, built of the same stone as the famous Chicago Water Tower, is on the left. Facing it is the office, a postmodern building from the 1960s, which is next to a rose garden and memorial site. Ahead are old barns and sheds used by the workmen. Inviting paths lead off to the intriguing stones and monuments.

In this book, we highlight the unique features of Mount Greenwood Cemetery, beginning with a short history. Geology will answer the question of why a cemetery was established here. There are famous residents, the infamous, and people with interesting stories to tell buried within. Social and civil groups have erected monuments here; while veterans, police, firemen, and the unnamed victims of disasters are honored.

Funeral customs have changed over the years, and Mount Greenwood Cemetery reflects this. The Victorian nature of the landscape is due to Willis N. Rudd, a famous local landscape designer, horticulturist, and educator. Leagues of stone carvers and monument makers, often associated with the Art Institute of Chicago and other local cultural groups, created a sprawling landscape dotted with large, unique monuments, mausoleums, and memorials, which give testament to generations of Chicagoans.

The 21st century is an era of large cemeteries with corporate owners and mergers, but Mount Greenwood is unique. It is still owned by the Mount Greenwood Cemetery Association, a small organization of people who still live in the neighborhood and have been quiet leaders in their community. Their most-used service is for family historians and journalists interested in local history and genealogy details.

The cemetery is populated with early pioneers from the Chicago area and present-day heroes. There are educators, artists, veterans, journalists, businessmen, social reformers, heroes who stepped up in a time of need, and ministers, as well as everyday people, including those who lost their lives in an epidemic or a horrific disaster. It encapsulates many historical events and people in the Chicago area.

Social and civil groups have erected monuments over the years, such as the Masonic column and Elks Rest. Tree stones, emblematic of the insurance group Woodmen of America, can be seen. Individual stones are carved or marked with the symbols of the National Society Daughters of the American Revolution (NSDAR) and other social and civic organizations.

Unnamed victims of disasters are honored, including those of the Chicago Water Crib Fire, the Christmastime fire at the Iroquois Theater, and the disaster aboard the SS *Eastland*. Police and firemen killed in the line of duty and other horrific events are also honored here. One continuing theme in this book is that, since the 1950s, we have taken vaccinations, immunizations, and antibiotics for granted. Prior to the 1950s, many families were devastated when a parent or several children did not survive typhoid fever, diphtheria, influenza, measles, or scarlet fever. Infections following surgery and what, today, would be minor injuries often resulted in death. Often, the loss of a family's mother or breadwinner forever changed the lives of the survivors.

We made the decision early on that this would not be a book of grave markers or headstones but, rather, images of people. In only a few instances were stones photographed, either because high-quality photographs could not be found or because they were too expensive to purchase. We hope that you enjoy the images and the stories of the families of Mount Greenwood Cemetery. Many of you helped to write it, and we thank you for sharing your family lore and photographs. We apologize for not being able to include all of your family members and to those local historians who would have liked other families included. We welcome more of your stories too. If you do not find your family or your story in this book, write, call, or e-mail Mount Greenwood Cemetery. With over 100 extra photographs and more stories to tell, maybe we should compile a second book?

One

AN IDEAL LOCATION, AND THE HISTORY OF THE CEMETERY

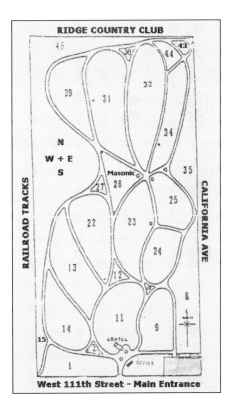

Mount Greenwood Cemetery is ideally situated on a glacial moraine and a sand dune that formed in old Lake Chicago. The slightly rolling terrain, with its diverse mix of hardwood trees and open prairie on winding roads, is a visitor's first impression of this classic Victorian cemetery. For generations, this parklike atmosphere has drawn families and local residents. (Courtesy of MGCA.)

The 1909 edition of *Moran's Dictionary of Chicago and Its Vicinity* described Mount Greenwood Cemetery as follows: "This beautiful home of the dead is very appropriately named, as the ground on which it is laid out reaches an altitude of seventy feet above Lake Michigan, and is perhaps the highest piece of natural ground within a like distance from Chicago. Nature has also provided one other feature necessary to the adornment of a park or large burying ground, and that is forest trees; here they are abundant, some of them monsters of the primeval forest." This is seen in the above early-1900s photograph. Moran's dictionary continues: "Mount Greenwood lies along One Hundred and Eleventh Street, California Avenue, and Western Avenue and is reached by the Chicago & Grand Trunk Railway, from Dearborn station, Polk Street, and by carriages, over well-kept roads, via Western Avenue, Halsted, and State streets." (Both, courtesy of MGCA.)

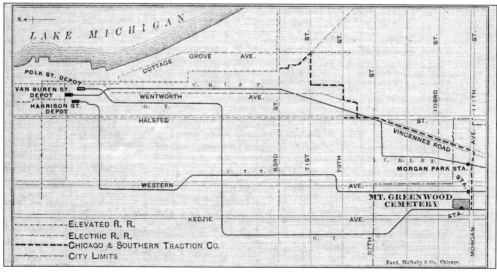

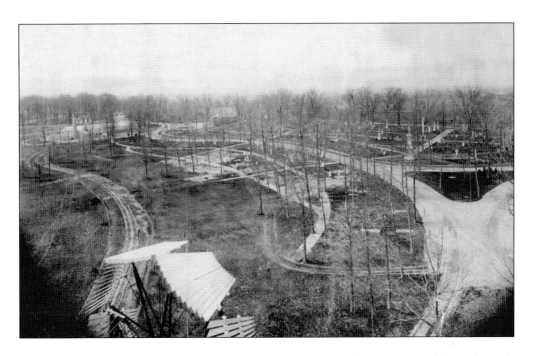

Moran's Dictionary of Chicago and Its Vicinity continues: "or the old Vincennes road through South Englewood. This cemetery may also be reached via Chicago, Rock Island & Pacific Railway; depot, Van Buren Street. The grounds contain eighty acres, and have greenhouses, water-works. It has been chosen as the resting place for the remains of many of Chicago's prominent and wealthy citizens, and it contains a large number of costly and appropriate monuments, among which is that of the Elks. The management of Mount Greenwood Cemetery Association is in capable hands, as will be seen by the following officers: James W. Brockway, President; Leslie P. Voorhees, Vice-President; Norman B. Rexford. Treasurer; Willis N. Rudd, Secretary." The above image is taken from the waterworks, and the below image shows the rolling sand dune and new landscaping. (Both, courtesy of MGCA.)

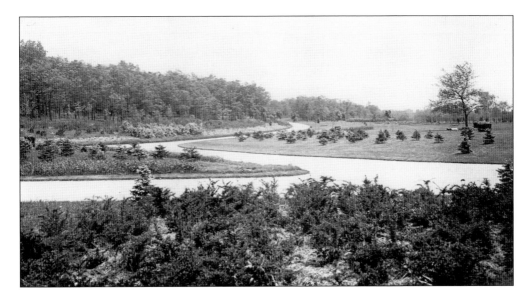

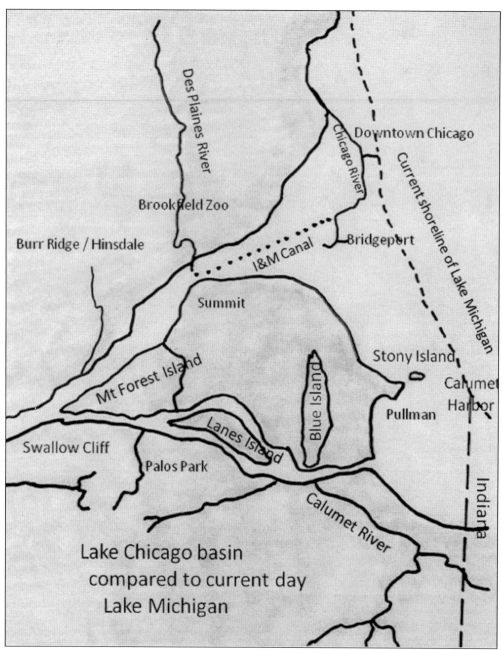

The Chicago area has been sculpted by numerous glaciers. The last one melted only 10,000 years ago, leaving behind a large prehistoric lake—Lake Chicago—surrounded by a ring of glacier moraines composed of gravel, clay, and sand and dotted with several gravel and sand islands. As the glacier continued to melt, waters weakened the moraines, and two openings drained the lake, leaving the islands behind. The northern opening is now called the Des Plaines River Valley, where the Stevenson Expressway Interstate 55, the Illinois and Michigan Canal, the Des Plaines River, and the Sanitary and Shipping Canals run. The southern opening is where Stoney Creek, the Calumet Sag Channel, and the Palos Swallow Cliff Forest Preserves are located. The current Lake Michigan shoreline is shown as a dotted line on this map. (Courtesy of MMK.)

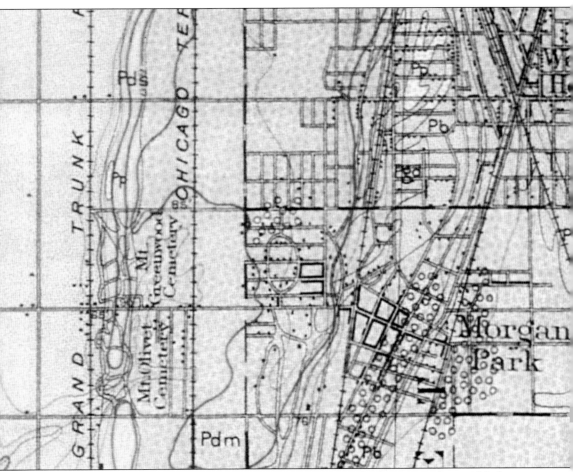

A former island, the Blue Island Ridge runs from about Eighty-Third Street to about 135th Street and is bisected by Western Avenue. Starting at the Dan Ryan Woods Forest Preserve, it includes the Beverly Hills, Mount Greenwood, and Morgan Park neighborhoods of Chicago, plus the cities of Blue Island and Evergreen Park. To the east, a 70-foot cliff runs along the Rock Island Railroad tracks. On the west side, as this 1904 survey indicates, the Grand Trunk Railroad parallels a long, thin slope of mixed beach sand (marked Pds) and small gravel (Pdm and Pgd), left behind when Lake Chicago drained. Students from the University of Chicago's geology classes have conducted digs analyzing the many soil structures in the cemetery. (Courtesy of the US Geologic Survey.)

The cemetery entrance is on 111th Street, and if the previous map were larger, one would see golf courses and other cemeteries to the north and south—built on the same sandy moraine soil. Per the *Martha Ladies Aid Society*, written in 1940: George W. Waite, a civil engineer, was evaluating the railroad in 1877, which ran from Blue Island Village into Chicago. He was impressed with the highest point in Chicago, a 70-foot-tall and six-mile-long ridge of sand and gravel that rose up west of the tracks. A vast sea of sand further west "was the proper vicinity for a rural cemetery. . . . They secured a charter and on July 26, 1879, Mount Greenwood Cemetery Association was formed." Those sandy hills were re-graded a century ago (above) but are still visible (below). (Above, courtesy of MGCA; below, courtesy of MMK.)

The first office and gate took the concept of a rural cemetery a bit too far: a rustic cabin (above), twig fence, and gate sat a few feet away from the dirt road that would become the four-lane 111th Street. In fact, per the *Martha Ladies Aid Society*, the first burial—in 1880—was described as occurring "after a day of tedious cortege journey over muddy country roads from Hyde Park." The obituary read, "At the residence of Mr. Rice, No 5320 Washington-av, Hyde Park, April 23, Mrs. Rachael Elizabeth Freeman, age 45 years." Her cause of death is not known, nor is her relationship to Mr. Rice. Shortly afterwards, a two-story limestone office (below) was built, and white post-and-wire fencing surrounded the grounds. Note the wooden plank sidewalks and the narrow, unpaved surface of 111th Street. (Both, courtesy of MGCA.)

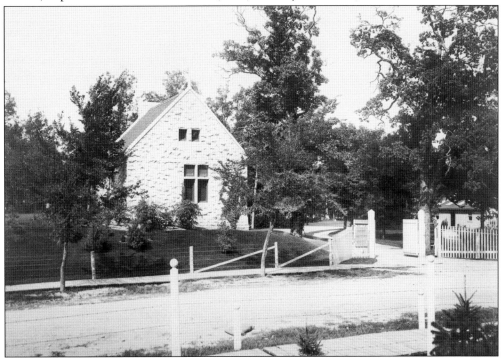

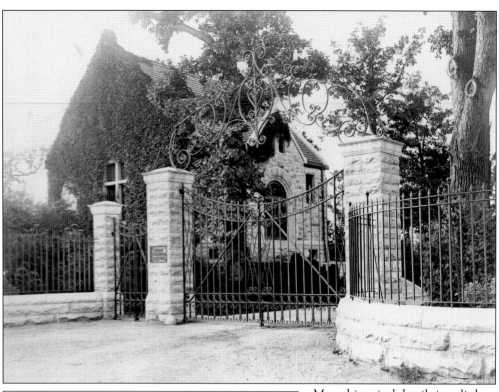

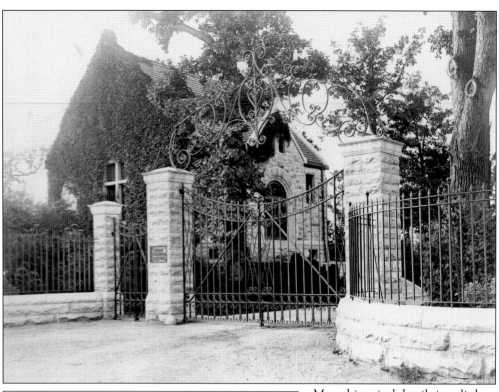

Many historical details interlink in the southern Chicago region. For example, the picturesque columns supporting the wrought iron gates in the above photograph were installed in 1899 (see the letter at left) and are constructed of a warm yellowish limestone quarried in Lemont, Illinois. It is the same stone used to build the Chicago Water Tower, which survived the 1871 Chicago Fire, and is still called "Athens Marble." The stone is called this because it is quarried in Lemont, which was originally named Athens. Also, marble is simply limestone that has been subjected to extreme heat and pressure within the earth. (Both, courtesy of MGCA.)

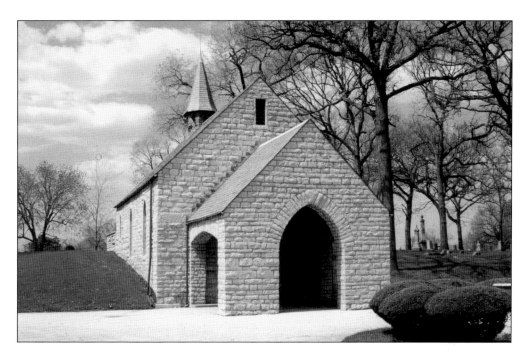

Set against large oak trees, the current chapel (above) is reminiscent of a 15th-century country church in England with its pointed Gothic windows, a strong portico in front, and a classic pointed spire on the dark roof. It seats 100 people. Erected in 1892 of the same warm limestone as the entrance gates, it originally served as a horse barn and workroom (below) for landscaping staff. It was rebuilt in 1937 by the family of Willis N. Rudd in memory of his long service as Mount Greenwood's director. (Both, courtesy of MGCA.)

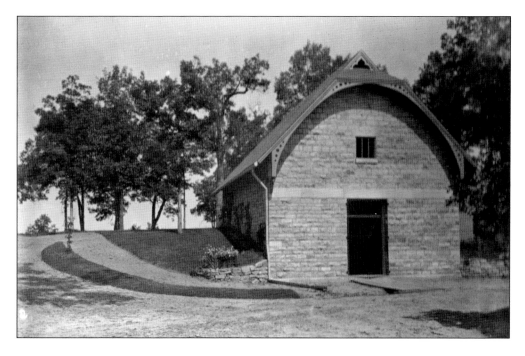

Mount Greenwood Cemetery

Prices in Effect February 1, 1905

Supt's and Secy's Address
Mail, Telegraph, Express
Mt. Greenwood, Ill.
Telephone Morgan Park 42

City Office,
Room 1411 First National Bank Bldg.
Chicago
Telephone Central 5179

As the population of southern Cook County boomed and railroads transported many businessmen from the new suburbs and into the city, the cemetery's business expanded. By 1905, a second sales office (above) was centrally located in downtown Chicago. Finally, in the early 1960s, this modern office (below) replaced the old stone office building. Furnished in period decor, it is a ranch-style building set among old oak trees and next to the Garden of Remembrance. (Above, courtesy of MGCA; below, courtesy of MMK.)

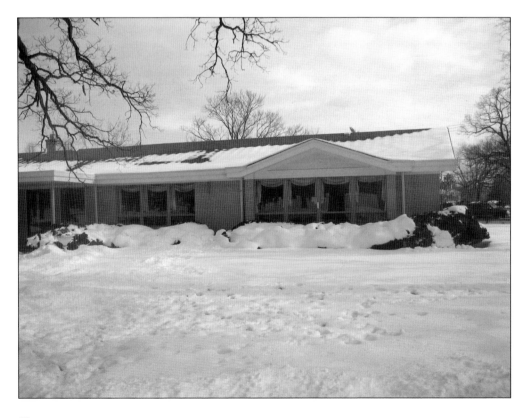

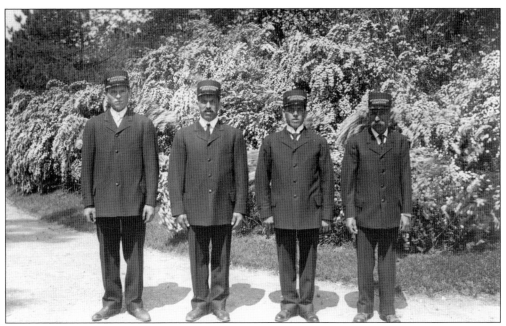

The above well-dressed gentlemen were guards, watchmen, or footmen from the early 1900s, often stationed at the front gate to assist visitors and direct funeral corteges. Note their caps, labeled "Mt Greenwood Cemetery." Many neighbors remember, or have family lore of, a family member working for the cemetery as a permanent staff member or as summer help weeding and planting. In the early 1900s, women had few job opportunities and often took on menial responsibilities. Written on the photograph below—from the cemetery archives—is, "13 reasons why there are no dandelions at Mount Greenwood Cemetery." (Both, courtesy of MGCA.)

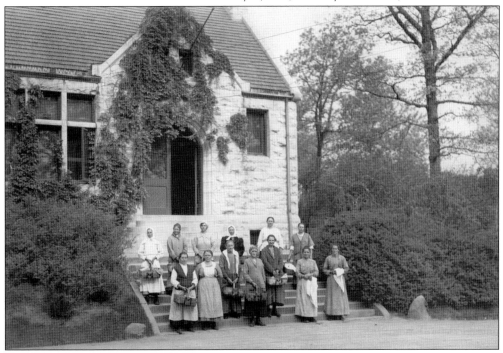

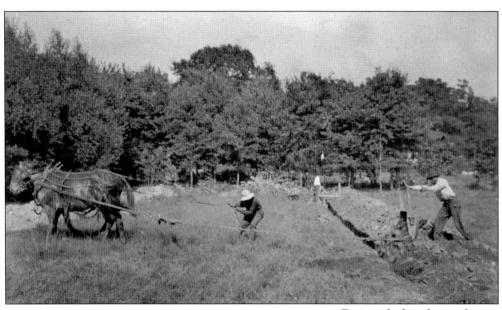

To the Horse Owners of Chicago and Vicinity:

May 15, 1920.

The horse shoers of Chicago are compelled to grant their workmen an increase in wages of $2.00 per day. To meet this expense and also to cover the increased cost of shoes, steel, pads, tar, oakum and nails the prices for each of the following items after June 1st, 1920, will be:

New Shoes, $1.25	Rubber Pads, 1 to 6,	$0.75
New Tips, .90	Rubber Pads, 7 to 10,	1.00
Shoes Set, .90	Rubber Shoes, 1 to 6,	1.60
New Bars, 1.50	Rubber Shoes, 6½ to 9,	1.80
Bars Set, 1.00	Nail Pads,	.25
	Shoes Re-nailed, .50	

This will make an average additional cost of about 75 cents a horse.

It will be understood that horse shoers, in view of the general industrial unrest, are as unable to stabilize their prices as any other class of business men who have to deal with organized labor and purchase their supplies from a market over which they have no control.

Respectfully yours,

Seagut

Think J. would until he says of C.

Will it be ok to keep deducting 10% as we have been doing

Even with the advent of automobiles in the early 20th century, horses remained a low-cost work tool in many business environments. Through the 1930s, horses worked in the cemetery during the winter and summer. Many photographs of horses are in the cemetery's archives: building roads and trenches, hauling water in large barrels, and transporting flowers. In a cemetery known for its beauty, the manure was probably an added bonus. These draft horses required a lot of care, as shown by the letter at left, from 1920, that explains that the cost of shoeing a horse has gone up about 75¢ per horse, as "horse shoers . . . are as unable to stabilize their prices as any other class of business men." (Both, courtesy of MGCA.)

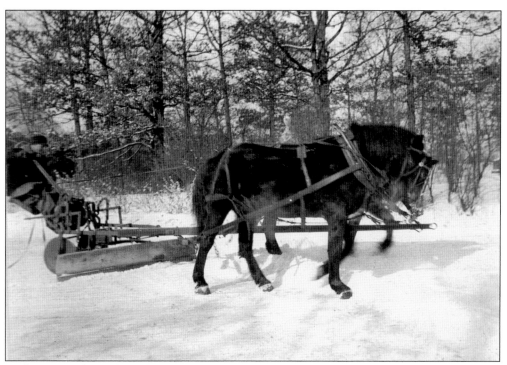

In this image above, from the 1930s, a team of horses is clearing roads by pulling a snowplow. But times change, and—in the more than 70 years since the 1940s—gasoline-powered plows, trucks, and lawn care equipment have become the norm, though graves and plots are still dug by hand. The current landscaping staff, pictured at right from left to right, are Luis Martinez, the current foreman; John Van Altena, the former foreman for many years; Godofredo Melero; and Gregorio Melero. Felix Melero is not pictured. These men have, combined, worked here for over 150 years. (Both, courtesy of MGCA.)

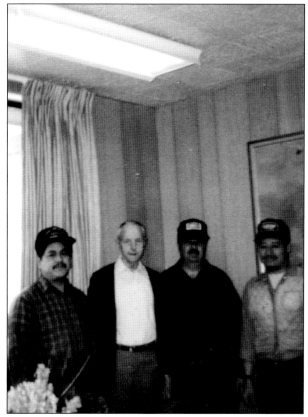

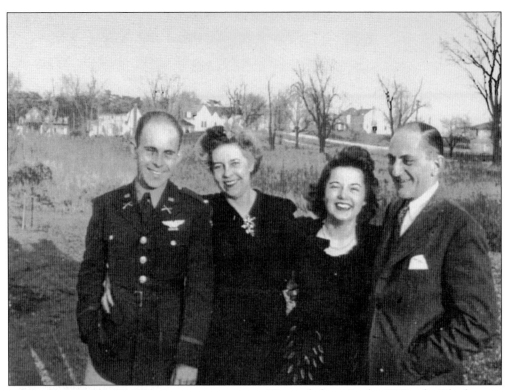

Pictured above in the 1940s, the Klenk family (from left to right), Ted (Paul Jr.), mother Caryl, wife Joan, and Paul Sr., have been associated with the cemetery since the 1920s, when the Old Blue Island Cemetery closed. Paul Sr. (left) and his wife, Caryl Nickerson, were lifelong Blue Island residents. He was high school class president all four years and graduated from Northwestern University's law school. He was elected city attorney in 1917 and then mayor of Blue Island, running unopposed for four terms. He represented a group of Robbins, Illinois, residents in 1917, in their Cook County Court petition to incorporate the first black community in Illinois. He was also named assistant attorney general to the State of Illinois in 1929 and served two terms. A World War I veteran, he organized Blue Island Post No. 50 of the American Legion. (Both, courtesy of the Klenk family.)

Paul T. "Ted" Klenk Jr. continued his father's commitment to veterans and served as president of the Cemetery Association until his death in 1992. Seen at right as a Morgan Park Military Academy graduate, he later married Joan Launspach, one of the twin daughters of the local pharmacist. Ted served in the Army Air Corps, initially as a 2nd lieutenant and then as a bombardier, flying 17 missions over Japan and earning a Purple Heart. On one flight near Iwo Jima, the plane ran out of fuel. Three men died, but Ted—along with others—was rescued by a merchant ship after spending eight hours on a raft. Joan worked as a technician at Loyola's dental school until their children were born. Ted was director of the Illinois Cemetery Association and president of the Greater Chicago Area Cemetery Association. (Both, courtesy of the Klenk family.)

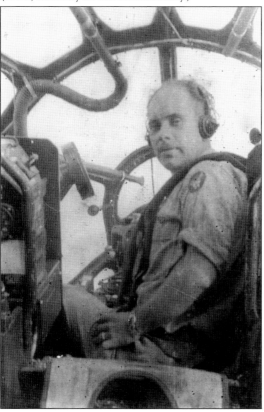

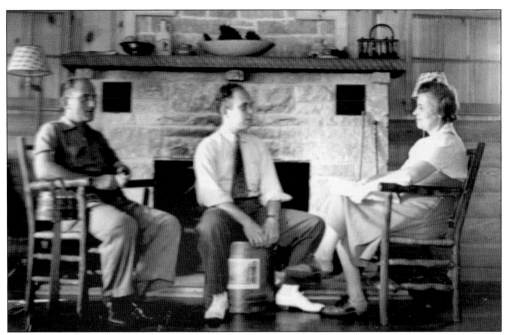

This 1940s photograph shows the Klenk family (above, from left to right), Paul Sr., Ted, and Caryl, at their weekend cabin in Orland Park, Illinois. Unfortunately, Paul Sr. died suddenly at age 58. Ted took over operation of the cemetery, and his daughter Paula continues the family tradition. In the below employee photograph from the 1980s are, from left to right, (first row) Paula Everett and Franklin Klein; (second row) Dan Everett, Carol Zajac, and Jim Klenk. Together, they now have over 100 years of service to the cemetery. Franklin Klein graduated from the University of Chicago Law School and was a well-known education law attorney. In 1936, he and Paul Klenk Sr. formed a law office in downtown Chicago. Mel Nielsen, who is not pictured, also worked at Mount Greenwood for many years. (Both, courtesy of the Klenk family.)

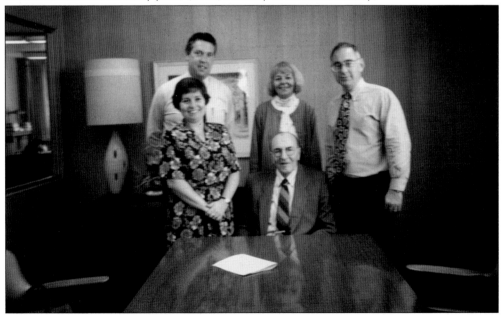

Landscape designer Willis Nathanial Rudd's artistic influence can still be seen at Mount Greenwood Cemetery, even after 100 years. He was a local, born in Worth Township in 1860, who graduated from Cornell University. This famous horticulturist created the Division of Floriculture at the University of Illinois in Urbana and, in 1915, began teaching a course on integrating the topography of a site with a naturalistic landscape design for cemeteries. He served as secretary of the Advisory Committee for the University of Illinois Experimental Agricultural Station. The lake in the below 1939 photograph no longer exists, but it demonstrates his artistic talent. (Right, courtesy of BIHS; below, courtesy of MGCA.)

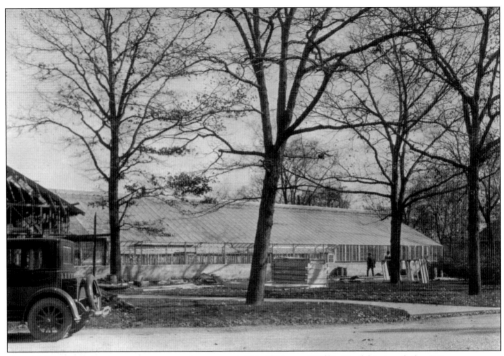

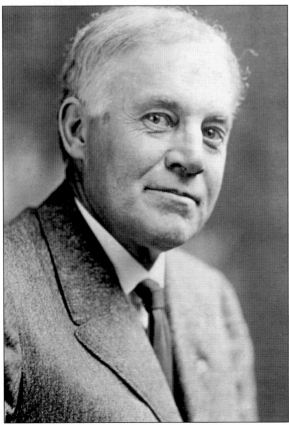

Willis Rudd joined the Mount Greenwood Cemetery Association as superintendent in 1886 and oversaw the construction of the greenhouses at the cemetery. He was president of the American Chrysanthemum Society, president and editor of the *American Florist Magazine*, and was actively involved in the formation of the Chicago Horticultural Society in 1890—serving as secretary and president. The society's first Chrysanthemum Show was held at the newly constructed Art Institute of Chicago for the Columbian Exposition 1893 Chicago World's Fair. Rudd was a judge at many garden shows, including the Louisiana Purchase Exposition 1904 St. Louis World's Fair. He married Julia Massey from Blue Island in 1883, and they had three daughters: Helen (Mrs. Ray) Arnold of Galesburg, Margaret (Mrs. Kellogg) Speed of Highland Park and Phyllis (Mrs. Norman) Seim, of Chicago. (Above, courtesy of MGCA; left, courtesy of BIHS.)

Two

FUNERAL CUSTOMS OVER THE YEARS

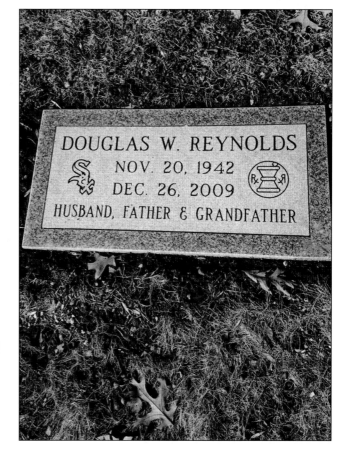

Funeral customs have changed over the years. Today, etchings of hobbies, jobs, and interests are popular. Douglas W. Reynolds, a life-long Chicago White Sox baseball fan, was buried with a Sox cap in his hands. His proudest achievement, besides his four children, was being a registered pharmacist—a career choice that he made as a youngster, while working with the owner of the Monterey Pharmacy, Henry Launspach. (Courtesy of Linda Reynolds.)

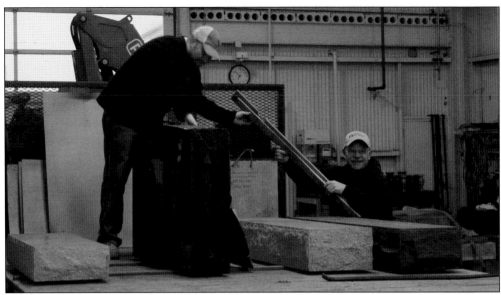

Walking through the cemetery, it is easy to note grave marker styles across three centuries. Ornate styles were popular in years past, and emblems showing interests and group memberships abound. Some grave markers look to a heavenly life, while others tout accomplishments, and crosses and statues of saints remain popular among Catholics. Cremations have grown in popularity, but family and group monuments and mausoleums still have appeal. Still an art form, monument maker Casey Ladislas (below) creates a unique memorial, while (above) Rick Kardosh (left) and Brian Tennis (right) load markers onto a truck. (Both, courtesy of Brian Tennis of DOH Services, Inc.)

The beautiful blue-gray monument at right was purchased by the Brockway family and is one of four "zinkies"— along with another monument and two markers—in the cemetery. Commonly called "white bronze," they are neither white nor bronze in color. Cast molded into various pieces of zinc carbonate, these memorials were significantly less expensive than granite and marble and have a beautiful blue-gray patina. Stone carvers and monument dealers derided them as cheap imitations of stone, but, even after 120 years, they have stood the test of time. The Brockway monument was included in the 1888 advertising brochure below, with testimonials from scientists to its superior quality. The American White Bronze Company's manufacturing plant in Grand Crossing (a Chicago neighborhood located at what is now about Sixty-Third Street and the Dan Ryan Expressway) finished many of the zinkies across the country. (Both, courtesy of MGCA.)

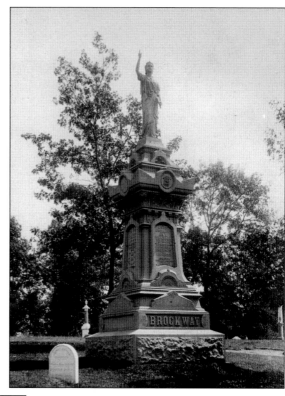

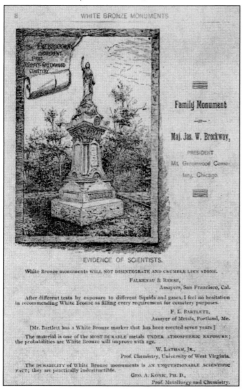

Tree stone monuments were very popular in the 1920s. Note the calla lilies and roses on this example. There are also tall monuments that look like trees. The Woodmen of America Insurance Company at one time supplied their members' markers. Many interesting markers and monuments abound in this cemetery. (Courtesy of MGCA.)

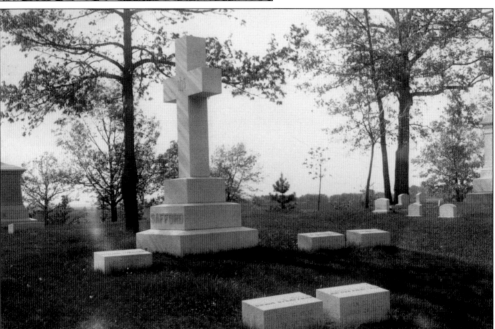

This cross honors members of the Safford family. Early residents of Blue Island, several Saffords were initially buried in the Old Blue Island Cemetery and later re-interred here. Isabella and H.H. Candee—the brother of Anne Safford—are buried here. Mrs. Candee was the first president of the Illinois General Federation of Women's Clubs. (Courtesy of MGCA.)

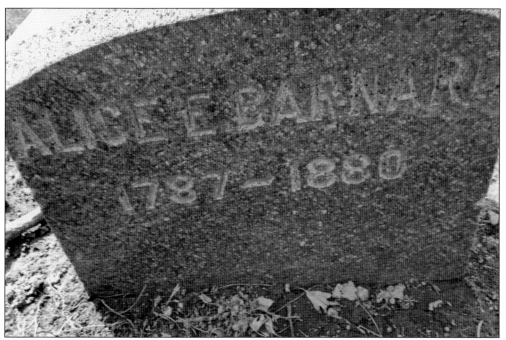

Alice E. Barnard, was born in 1785, two years after the American Revolutionary War ended. The stone, pictured, is incorrectly dated as 1787. Barnard died in 1880, at age 95, and was one of the first burials in Mount Greenwood as well as the earliest birth date in the cemetery. She was the grandmother of educator Alice L. Barnard. (Courtesy of MGCA.)

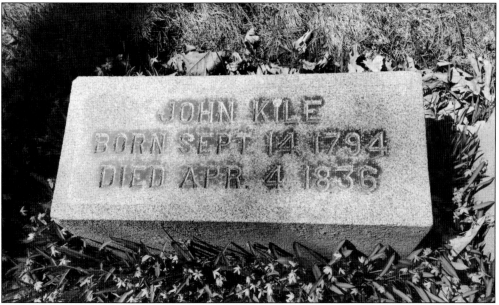

The earliest death date in the cemetery is that of an early settler from Will County, Illinois. Maj. John Kile (Kyle) died in 1836 when a tree fell on him. He was initially buried near his farm in Beebe's Grove (now Crete) but he was re-interred here, along with other family members. The family's Kyle's Tavern was located at what is now Eighty-First Street and Vincennes Avenue. This historic Blue Island family had many burials here. (Courtesy of MGCA.)

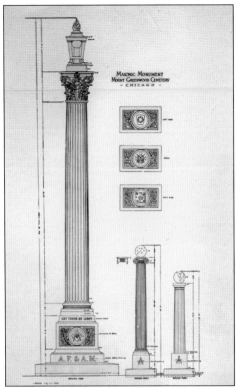

The 36-foot-tall Masonic Monument in the cemetery was installed by the Charles G. Blake Monument Company, and it is flanked by two more monuments—one 15 feet tall and the other 11—one of which has a globe of the world on it while the other bears a globe of stars. The photograph below gives a good idea of the scale of the tallest monument by comparing it to Mr. Blake, who is standing by the uppermost piece. He was one of the first members of the Rotary Club, a member of Ridge Country Club, a Mason, an Elk, an honorary member of the Chicago Architectural Club, and a lifetime member of the Art Institute of Chicago. He was Chicago's foremost monument contractor in the early 20th century. (Both, courtesy of MGCA.)

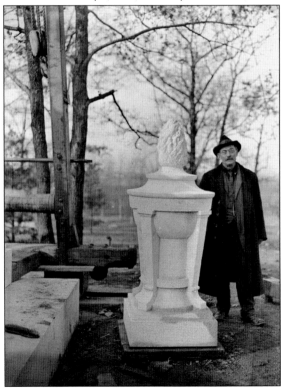

A crane was required to install the Masonic column. Charles G. Blake hired many skilled men to produce both small and large monuments and mausoleum buildings. Many of the markers and sculptures in Mount Greenwood Cemetery are from his shop. He was born in England and formed his company in Englewood in the 1880s. He and his wife, Mildred Ellwood, were residents of Morgan Park. A promoter of the arts, he was also the director of both the Calumet Trust and Savings Bank in Morgan Park (the building housed the Beverly Area Planning Commission [BAPA]) and the Stony Island Trust and Savings Bank. (Both, courtesy of MGCA.)

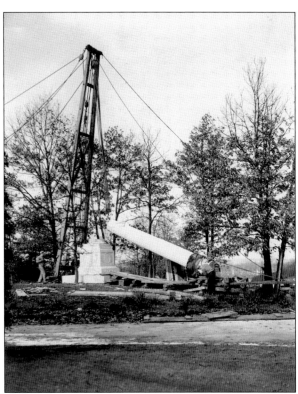

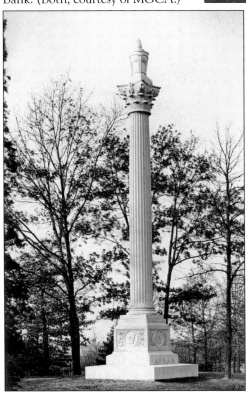

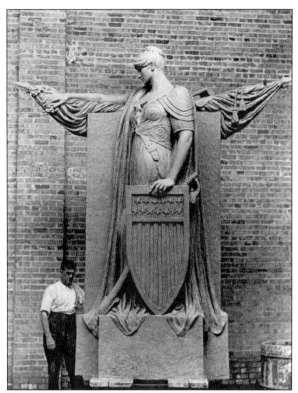

Charles J. Mulligan, born in Ireland and buried here, is one of the most recognized sculptors in the United States. His public works include *Lincoln the Railsplitter*, in Chicago's Garfield Park, and *Home, Miner, and Child*, in Chicago's Humboldt Park, which demonstrate the realistic and humanistic style for which he was praised. He also produced *Peace Monument* for Decatur, Indiana (left), and a statue of Henry Clay for Lexington, Kentucky—shown below during production. He was working at the Pullman factory when he was discovered by the sculptor Lorado Taft. As an instructor at the School of the Art Institute, his work was part of the "Chicago Beautiful" urban planning movement promoted by Daniel Burnham's Plan of Chicago. The beautification of urban areas with neighborhood parks and statuary created ample opportunities for Mulligan to use his considerable skills. (Both, courtesy of MGCA.)

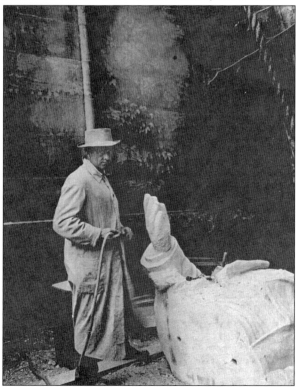

The national headquarters of the Benevolent and Protective Order of the Elks (BPOE) is located near Chicago's Lincoln Park. But Elks Rest, pictured here is the only one in Illinois, and is the site of almost 150 burials. Initially formed as a social club for theater people in 1866, the Elks have evolved into a very active service organization and now have about 1 million members of all races and religions and both genders. They raise funds and provide numerous services for military families and veterans, services for children, and numerous social help programs in their communities. (Both, courtesy of MGCA.)

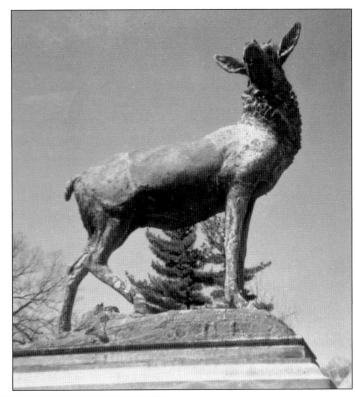

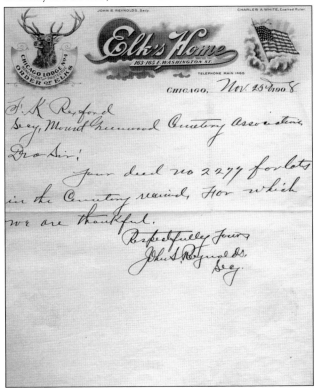

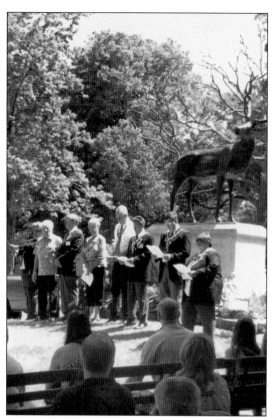

Installed by Chicago's Lodge No. 4, the dedication of the monument in 1882 included an orchestra with an opera company. Three trains, consisting of 42 cars, transported 200 Elks members and 2,000 guests to the cemetery. The monument's granite base is from Hallowell, Maine. The first elk, shown on the previous page, was made of white bronze and was replaced in 1984—after 102 years—with the fiberglass model pictured at left. Unfortunately, this second elk had real antlers, which attracted chewing animals due to the calcium and other minerals naturally found in bone. In 2012, a bronze-covered aluminum statue was dedicated (below). Elks Rest was founded under the credo of "Living or Dead an Elk Is Never Forgotten, Never Forsaken." (Both, courtesy of MGCA.)

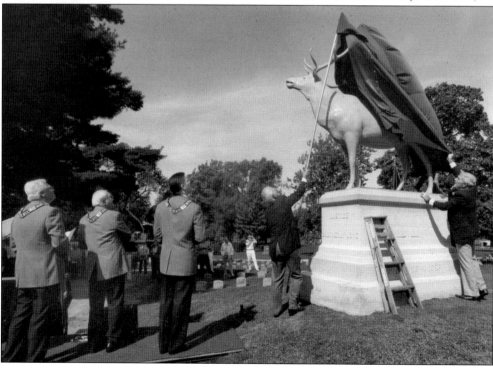

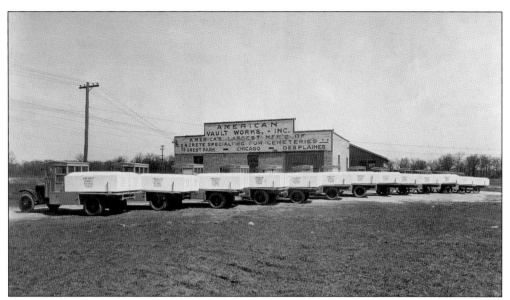

The American Wilbert Vault Company was founded as the Haase Company in Chicago in 1880 and is the largest supplier of burial vaults in the country. Vaults are concrete structures put in the ground to protect the caskets. This family-owned business has evolved into a franchise structure, with operations nationwide. By 1981, six million Wilbert vaults had been sold. The above photograph is from the 1920s, and the one below was taken at the Rockford, Illinois, plant in 1956. The drivers are, from left to right, Ray Hoffman, James Dempsey, Jess Kruit, Ross Whipkey, and Eldon Edwards. (Both, courtesy of the American Wilbert Vault Company.)

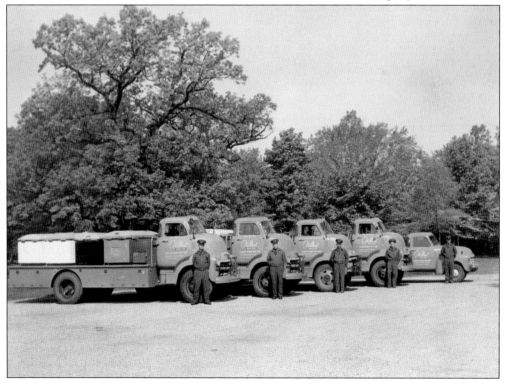

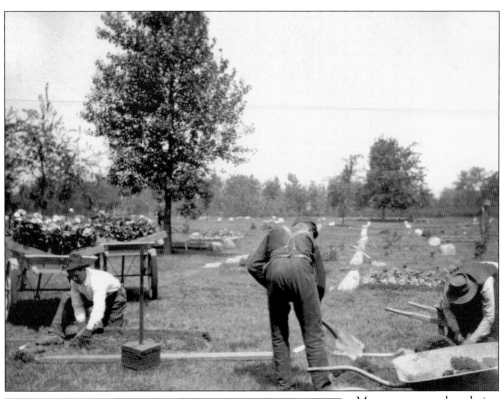

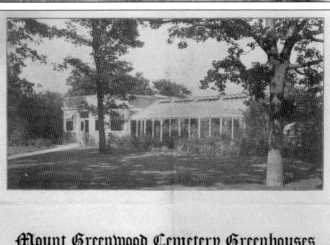

Mourners remember their families in many ways. Some place fresh or long-lasting flowers throughout the year, or maybe a flag on Memorial Day. Others set a Chicago White Sox baseball team flag next to a gravestone to remember die-hard fans who did not live to see the White Sox win the World Series in 2005. In the early image above, three gardeners install a plot planting from two carts filled with begonias or carnations, while numerous plantings and flowers can be seen in the background. The extensive greenhouse seen on the flyer at left once provided a wide variety of bedding flowers, though it has since been demolished. (Both, courtesy of MGCA.)

Stueber Florist and Greenhouses, on 111th Street in Mount Greenwood, has been in business for over 70 years. It has provided an easy source for families purchasing flowers or memorials since 1943. Mount Greenwood Cemetery also provides a service in the spring and fall where one can order everlasting winter wreaths or spring bouquets that are placed by cemetery staff. (Courtesy of MGCA.)

Funeral customs have changed over the years. Today, many families prefer cremation or a simple service in the Garden of Remembrance. Cemeteries provide a place to visit and remember loved ones and to introduce children to their departed family members by telling stories of their accomplishments or the funny things that they said or did. (Courtesy of MGCA.)

Chas. E. Lackore

Undertaking and

Embalming

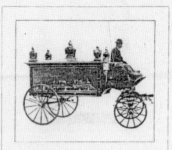

Livery in Connection

Telephone 21. Morgan Park, Illinois.

Most early funeral homes were initially livery stables, which rented horses, carriages, and wagons. From there, it was natural to progress to ornate funeral hearses, such as this gilded one (above) from 1904. Rental of horse-drawn hassocks, surreys, or carts for Sunday cemetery visits was the norm, often after taking one of several trains to 111th Street. The Lackore, Nichols, and Lane Funeral Home operated for 100 years in Morgan Park, located at the southwest corner of 111th Street and the Rock Island Railroad tracks from 1890 to 1980. DeWitt Nichols Lane, the nephew of founder Charles Lackore and Robert Nichols, continued to provide funeral services and support for local families until his death in 1990. Sadly, this beloved, family-owned institution died with him. (Both, courtesy of RHS.)

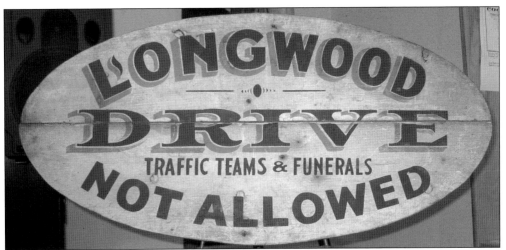

In 1912, the *Reminder* newspaper informed readers that "traffic teams and funerals would be strictly kept off of Longwood Boulevard," as it "was part of Chicago's pleasure driveway" system. The 1909 Burnham Plan had designated over 25 miles of streets, including Sheridan Road, Michigan Avenue, Congress Parkway, and Garfield Boulevard, to connect city parks. Ironically, automobiles and trucks would soon replace horses and oxen. (Courtesy of RHS.)

The Regular Funeral Train leaves Chicago daily (Sunday included) at 12:00 noon, via Chicago & Grand Trunk Railway, from Dearborn Station, corner Third Avenue and Polk St.

TIME TABLE.

LEAVE M.	STATIONS.	ARRIVE P.M.	Rates on the Regular Funeral Train are as follows :
12.00Chicago............	3.35	
12.10Archer Avenue........	3.25	
12.2447th Street.........	3.11	Single Fare to Mount Greenwood, - - $ 0 39
12.25C. & W. I. Junc.......	3.10	Round Trip Rate (if Ticket is procured and used on
12.26Halsted Street.......	3.09	Funeral Train on date of issue) - - - 45
12.29Ashland Avenue.......	3.06	
12.31	...C., St. L. & P. Junc......	3.04	Special Ticket for Corpse, - - - 50
12.34Morrell Park.........	3.01	Funeral Car, limited to 30 passengers, - - 10 00
12.35Elsdon...........	3.00	" " " 60 " - - 15 00
12.39Chicago Lawn.......	2.55	
12.42McCaffery..........	Each additional Car of 60 " - - - 12 00
12.44Hayford..........	2.52	
12.46Clarkdale.........	
12.51Evergreen Park.......	2.45	
12.56 Mount Greenwood.......	2.40	

Arrangements for Funeral Parties on the Train should be made with the Ticket Agent at Polk Street Depot AT LEAST FOUR HOURS BEFORE TRAIN TIME.

Suburban time card for *all* Trains stopping at the Cemetery can be obtained at the R. R. Stations.

The Rock Island Railroad, in Morgan Park, transported many funerals—with families renting carriages. In 1905, the Grand Trunk Railroad (now the Chicago Terminal Transfer Railroad) also had a depot at Sacramento Avenue. "We expect," reads an announcement, "the Mt. Greenwood funeral trains to excel anything of the kind heretofore known, and to be available on demand, for any emergency, at any station in Cook County." (Courtesy of MGCA.)

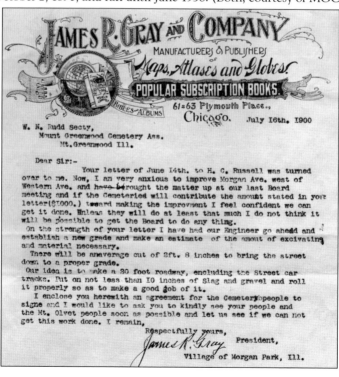

Mount Greenwood Cemetery

CHICAGO, ILLINOIS.

Depot at One Hundred and Eleventh Street and California Avenue,

ON GRAND TRUNK RAILROAD.

CITY OFFICE:
Room 53, No. 79 Dearborn Street.

GEO. W. WAITE, President.

DANIEL H. HORNE, Secretary.

CHARLES W. DEAN, Superintendent.

"P. O. Address, Evergreen Park, Ill."

(OVER.)

The announcement continues, "It is confidently expected that the general public will soon learn to appreciate an arrangement which will combine the elements of comfort, elegance and economy. The railroad will furnish the funeral car attached to one of the regular trains for $10, or will furnish a special funeral train to the same place for $25. Those who wish to reach the cemetery ground by the carriage roads will find all the public roads clear of toll-gates and free as the air." Train tickets, like the one above, put the railroad in competition with new streetcars. The letter seen below, from 1900, discusses plans to pave 111th Street and install a streetcar line. Funeral trains operated through the late 1930s. In metropolitan Chicago, the first electric streetcars began operation on October 2, 1890, and ran until June 1958. (Both, courtesy of MGCA.)

Until the 1950s, most residents relied on streetcars to shop, go to work, or visit family. On 111th Street, the streetcar tracks stopped just west of the cemetery, at Sacramento Avenue. This 1940s photograph looks east at the tracks, while the cemetery is visible on the left. Family lore has it that Ignatz Kish's funeral was conducted via streetcar. A Roman Catholic, Kish died suddenly and was buried here so that his wife, Marie, could easily visit him via the streetcar. Ignatz had learned carpentry from his future father-in-law in Hungary, and in Chicago, he wooed Marie with letters that encouraged her to emigrate. Employed by the Stewart Lumber Company, Kish also ran a carpentry business in his basement, and Marie was a much-appreciated seamstress in their community. (Right, courtesy of CTA; below, courtesy of Pearl A. Kish.)

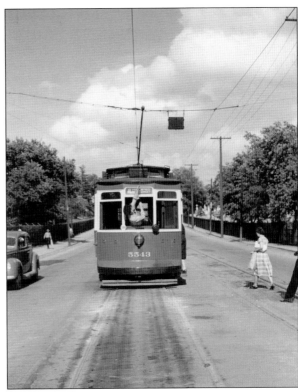

43

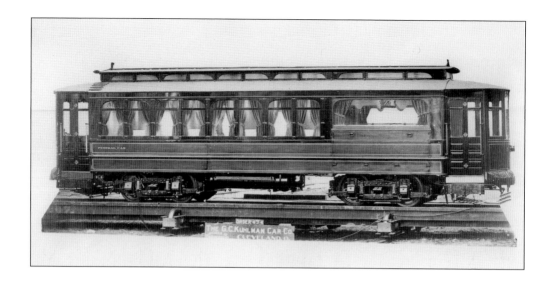

Funeral streetcars, specially built to accommodate families taking public transportation, were an innovative idea. From about 1900 to 1919, a well-appointed funeral car (above) came up 111th Street from the train stations. Both the deceased, in front, and the mourners, in the back, enjoyed plush—perhaps velvet—drapes, and stained glass windows. In inclement weather, canvas curtains on the outside could be drawn down. This unique Chicago Surface Lines funeral streetcar operated until 1919, when it was replaced by regular streetcar service. Today, railroad and streetcars have been replaced with contemporary vehicles, such as automobiles, limousines, and custom items such as the motorcyclist's dream below. (Above, courtesy of CTA; below, courtesy of MGCA.)

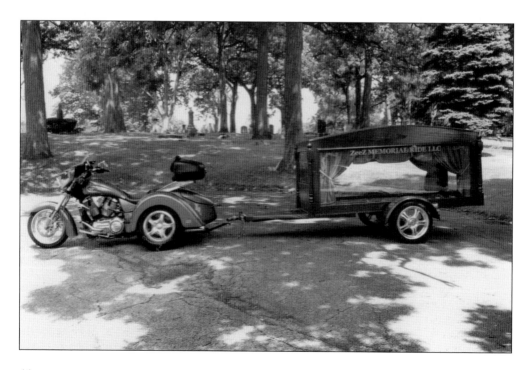

Three

PART OF THE COMMUNITY

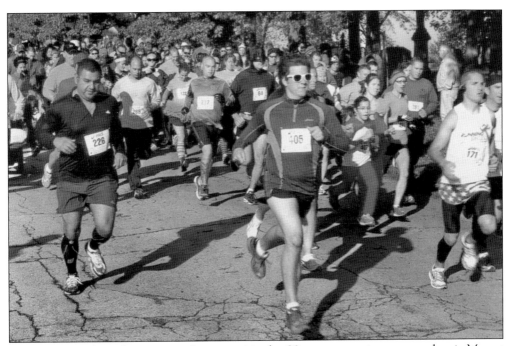

Each day, people walk, run, or otherwise visit the 80-acre open-air museum that is Mount Greenwood Cemetery. This makes it is the perfect place to host the Tombstone 5K Run/Walk, organized by Jim Pacente of Running Excels, on Western Avenue. It draws over 500 runners and walkers from across the Chicago area. Participants are encouraged to dress in costume for the October event. (Courtesy of MGCA.)

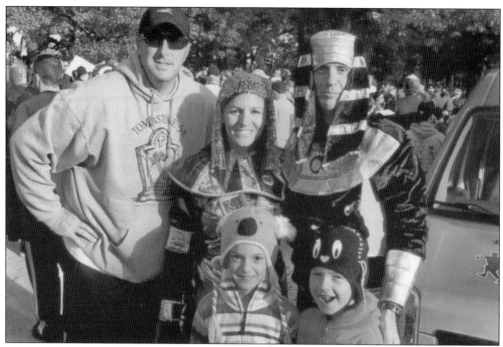

All proceeds from the Tombstone 5K Run/Walk go to two local charities. One is the Maeve McNicholas Memorial Foundation, which supports research of infant and child brain tumors at Children's Memorial Hospital in Chicago. The number of runners and walkers increases every year. Family events follow the marathon, and prizes are awarded for costumes and times. In the top photograph are, from left to right, (first row) Caroline and Madeline McKenna; (second row) Anthony McKenna, Beverly Lynch, and Jim Pacente. In the bottom photograph are, from left to right, (first row) Mattie Palmer, Emma Scislowicz, Kelly Blaha, Shannon Everett, Geneva Everett—with baby Izzy Everett—and Mike Blaha; (second row) Beth Palmer, Megan Scislowicz, Dave Everett; and Dan Everett. (Both, courtesy of MGCA.)

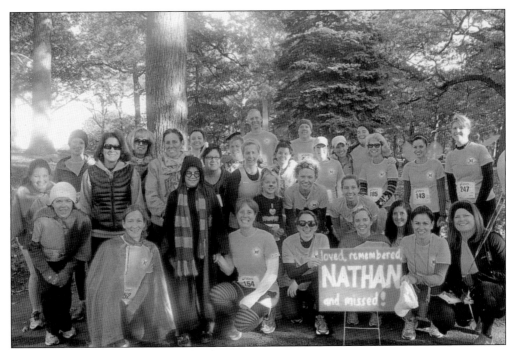

The other local charity supported by the marathon is Team Nate, which runs in memory of 11-year-old Nathan Dombrowski—who passed away following an accident in 2007. He is described as a diligent student, a good athlete, and a humble young boy, who touched many lives with his kindness; made himself comfortable wherever he was; and won people over with his smile and positive, fun-loving, hardworking attitude. Runners and walkers donate to the Heart Connection Family Bereavement Program at the Little Company of Mary Hospital, Evergreen Park, in Nate's honor. (Above, courtesy of MGCA; right, courtesy of Dombrowski family.)

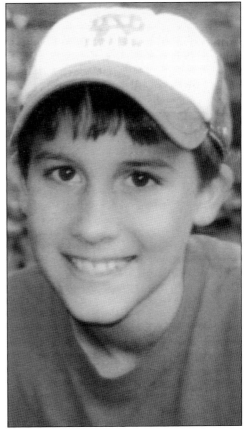

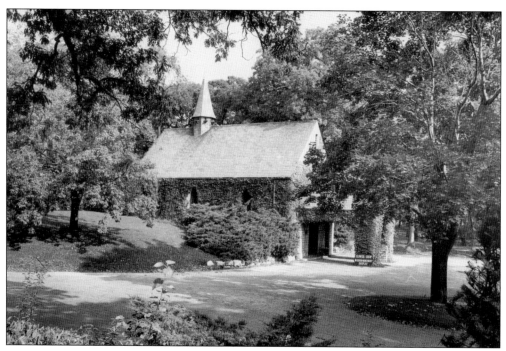

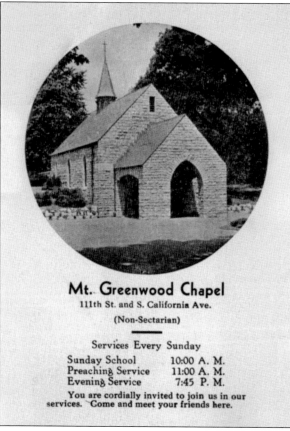

Mt. Greenwood Chapel

111th St. and S. California Ave.

(Non-Sectarian)

Services Every Sunday

Sunday School 10:00 A. M.
Preaching Service 11:00 A. M.
Evening Service 7:45 P. M.

You are cordially invited to join us in our
services. Come and meet your friends here.

Over the years, the chapel has been the site of many community functions. In the above photograph, the chapel is being used as a temporary office, florist, and monument display shop. It has also served as a church. The *Martha Ladies Aid Society* states that, "Since the Mount Greenwood cemetery officers, in the spring of 1939 offered the beautiful new chapel for the service of the (newly formed) Mount Greenwood Gospel Mission, the meetings are held there regularly every Sunday." This offer extended into the 1950s, when the chapel, with the ivy removed (photograph at left), was still used by local churches. (Both, courtesy of MGCA.)

The chapel's current primary purpose is for funeral services, but it also serves as a multipurpose meeting and program room. History programs—such as Story Time—and talks on local families and famous individuals are often held in conjunction with Ridge Historical Society or other local groups. It has also been used for weddings. (Courtesy of MGCA.)

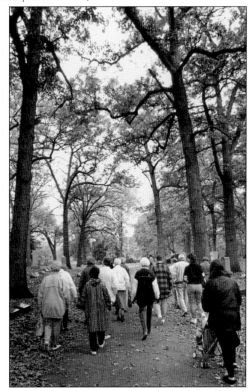

History programs are still very popular at Mount Greenwood. For example, this walking tour with reenactor, local historian, and naturalist Christine Brookes—dressed as Alice Barnard—was held in October 1992. It was sponsored by the Oak Lawn Park District and told of the Barnard, Wilcox, and Morgan families—early settlers and businessmen from the area. (Courtesy of RHS.)

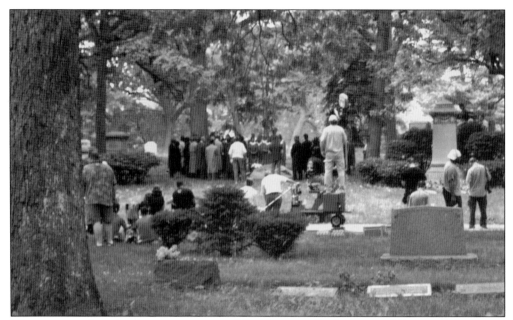

The cemetery has also been a movie set. *The Express* tells the story of Syracuse University graduate Ernie Davis, who became the first black Heisman Trophy winner in 1961. Drafted by the Cleveland Browns, he died of leukemia in 1963—having never played professional football. The film was released in 2009. In 1984, Jane Fonda won an Emmy Award for Outstanding Actress in the television movie *The Dollmaker*, which also filmed there. (Courtesy of MGCA.)

The Blue Island Cemetery on 127th Street was established in 1850, following a series of cholera epidemics. Records of burials have been lost, so transfers to Mount Greenwood Cemetery in the 1920s were difficult. Stones occasionally still appear on the old site. In 1935, a grant from the Works Progress Administration converted the site to a much-needed community park. (Courtesy of MMK.)

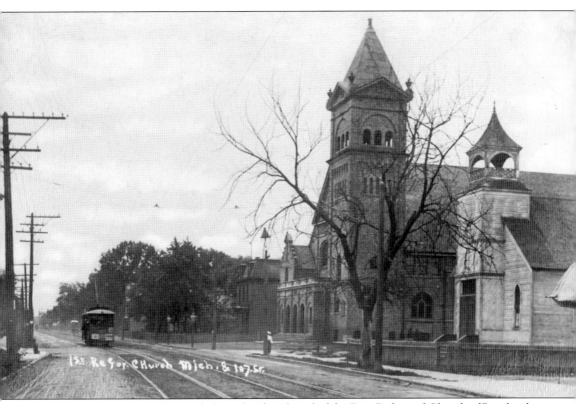
1st Re for Church Mich & 107 St.

In 1888, and again in 1928, burials from the churchyard of the First Reformed Church of Roseland were re-interred at Mount Greenwood Cemetery. The church was formed in 1849, and the first burial was probably in 1852. Detailed records were not kept, as the lots were not sold because church members had the privilege of using them. Grave markers were often made of wood, which deteriorated. In 1887, a larger brick church was constructed next to the old frame church. In 1888, when 107th Street was put though to Michigan Avenue, a number of graves had to be moved. This explains why there are markers with death dates from the 1850s through the 1870s at Mount Greenwood Cemetery. Then, in 1928, after the church sold property to the north, more pine coffins, mostly sized for babies, were found. Mount Greenwood donated a large lot for these re-interments. (Courtesy of CPL-HW.)

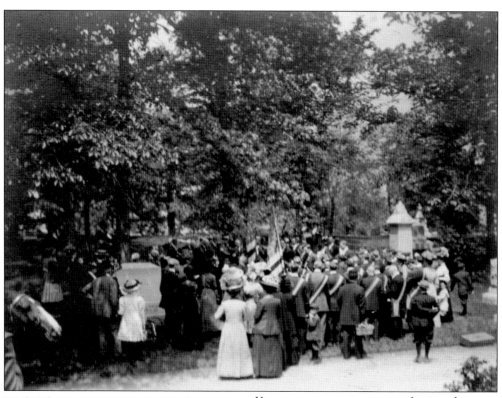

Years ago, cemeteries were gathering places for social events. Most people worked six days a week, with Sunday being the only day off. It was a perfect day to visit with family members and neighbors and picnic on the grounds of the cemetery. Memorial Day has always been one of the most popular days to visit the cemetery, as seen above. Civil War and Spanish-American War events held prior to 1918, and World War I events held after 1919, would draw large crowds. Trains would run on special holiday schedules. (Both, courtesy of MGCA.)

In 1900, the Grand Army of the Republic (GAR) sponsored a Memorial Day program. Today, over 325 Civil War veterans are buried here. In April 2013, to commemorate 75 recently placed gravestones, the Illinois Sons of Union Veterans of the Civil War (SUVCW), Phillip H. Sheridan Camp No. 2, presented a modified cannon. Shown below, from left to right, are Philip H. Sheridan Camp No. 2 national chaplain Jerome Kowalski; Chuck Wright; camp commander Marc Finnegan; Illinois Department commander Jody Switzer; past commander Jim Zingales; past Illinois Department member David Bailey; past Illinois Department commander Steven Westlake; Robert Rogers; and Robert Kurek. The original cannon, given in 1913 by L.H. Drury Post No. 467 (Grand Army of the Republic of Grand Crossing, Chicago, Illinois), had been stolen in the 1980s. (Both, courtesy of MGCA.)

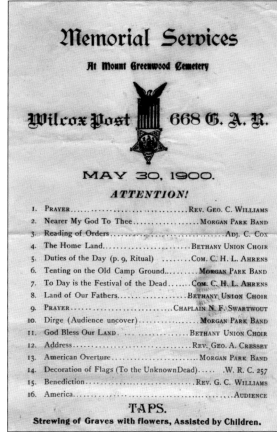

Memorial Services

At Mount Greenwood Cemetery

Wilcox Post 668 G. A. R.

MAY 30, 1900.

ATTENTION!

1.	Prayer	Rev. Geo. C. Williams
2.	Nearer My God To Thee	Morgan Park Band
3.	Reading of Orders	Adj. C. Cox
4.	The Home Land	Bethany Union Choir
5.	Duties of the Day (p. 9, Ritual)	Com. C. H. L. Ahrens
6.	Tenting on the Old Camp Ground	Morgan Park Band
7.	To Day is the Festival of the Dead	Com. C. H. L. Ahrens
8.	Land of Our Fathers	Bethany Union Choir
9.	Prayer	Chaplain N. F. Swartwout
10.	Dirge (Audience uncover)	Morgan Park Band
11.	God Bless Our Land	Bethany Union Choir
12.	Address	Rev. Geo. A. Cressey
13.	American Overture	Morgan Park Band
14.	Decoration of Flags (To the Unknown Dead)	W. R. C. 257
15.	Benediction	Rev. G. C. Williams
16.	America	Audience

TAPS.

Strewing of Graves with flowers, Assisted by Children.

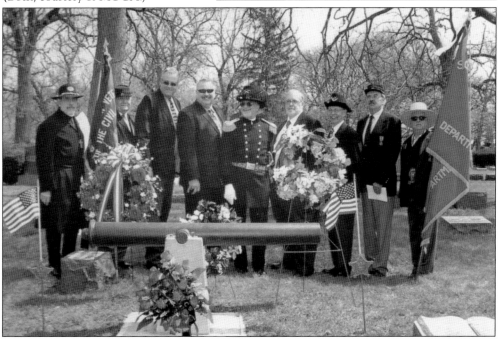

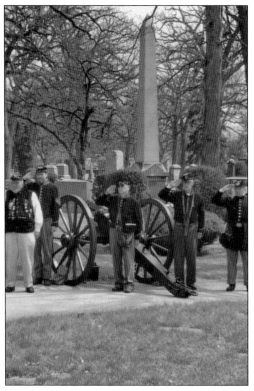

The SUVCW also brought their own cannon for the event. At left, the men saluting are, from left to right, Jeff Fiddler, Rob Hauff, Everett Nylund, Nick Kaup, and Tom Hauff. All are from Mulligan's Battery, Custer Camp No. 2. In 2007, Illinois lieutenant governor Pat Quinn (below, center) presented the "Hometown Heroes" award to Paula Everett (left) and Kim Demas (right) of Mount Greenwood Cemetery for their efforts petitioning the US Department of Veterans Affairs to engrave the headstones of veterans—particularly on unmarked graves. Preservation efforts continue, and events, such as those with the Sons of the Union Veterans of the Civil War, remind of the sacrifices of veterans. (Both, courtesy of MGCA.)

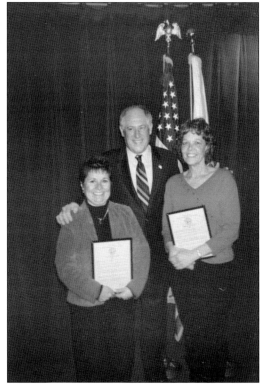

Four

HEROES AND DISASTERS

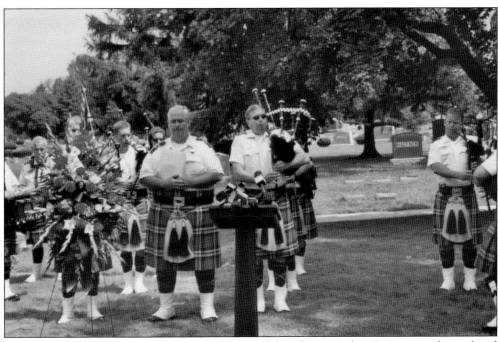

For over 15 years, since 1999, the Pipes & Drums of the Chicago Police Department have played at the funerals of suburban, county, state, federal and Chicago police and fire department officers. Composed of active law enforcement officers, they also provide headstones for the recently fallen, repairs of old stones, and place stones on unmarked graves. (Courtesy of MGCA.)

The Great
Chicago Theater Disaster

By MARSHALL EVERETT

The Well Known Editor and Descriptive Writer

THE COMPLETE STORY TOLD
BY THE SURVIVORS

Presenting a Vivid Picture, both by Pen and Camera, of One of the Greatest
Fire Horrors of Modern Times.

Embracing a Flash-Light Sketch of the Holocaust, Detailed Narratives by Participants in the
Horror, Heroic Work of Rescuers, Reports of the Building Experts as to the Responsibility
for the Wholesale Slaughter of Women and Children, Memorable Fires of the Past, etc , etc.

PROFUSELY ILLUSTRATED WITH VIEWS OF THE SCENE OF
DEATH BEFORE, DURING AND AFTER THE FIRE

Copyright 1904, by D. B. McCurdy.

PUBLISHERS UNION OF AMERICA

The Iroquois Theater Fire occurred on December 30, 1903. Stage lights set the curtains on fire and rapidly spread to the front rows. Blocked exits and narrow hallways turned the theater into a deathtrap for families, teachers, and children when a holiday adventure turned tragic. Ten of the victims rest at Mount Greenwood Cemetery: Henrietta Polzin; Maria Koehler and her daughter Lola, age 16; Hilga Berg, age 35, her son Victor, age 11, and her daughter Olga, age 11; Adelheid Cuthardt, age 41, and Elisa, age 15; John Hartman; and Arthur Carville, age 24. (Both, courtesy of MGCA.)

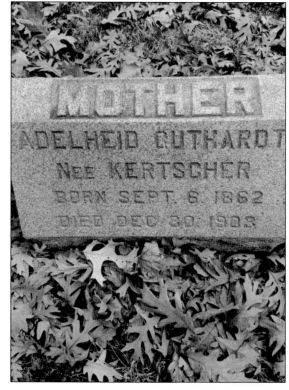

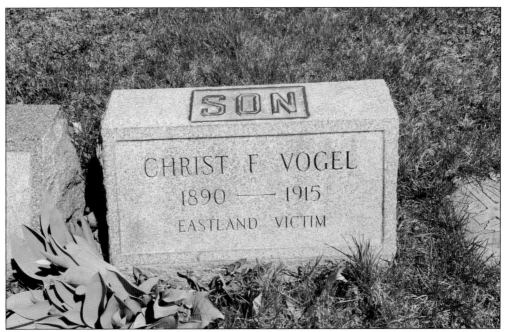

On July 24, 1915, over 844 passengers died when the top-heavy SS *Eastland*—chartered for a company picnic—rolled over in the Chicago River. Christ Vogel, age 25, died; but Esther Nelson Hughes—who also worked for the Western Electric Company in Cicero—and her husband, John, missed the disaster because they stopped to change baby Marguerite's diapers. Esther was terrified of water as, when her family emigrated from Sweden years before, she witnessed a burial at sea. John, born in County Kerry, Ireland, worked in a local foundry and was a well-known neighborhood handyman. He lived to age 89, and he walked miles to Roseland or Blue Island on every day of his retirement. (Both, courtesy of Sandy Hughes Rollberg.)

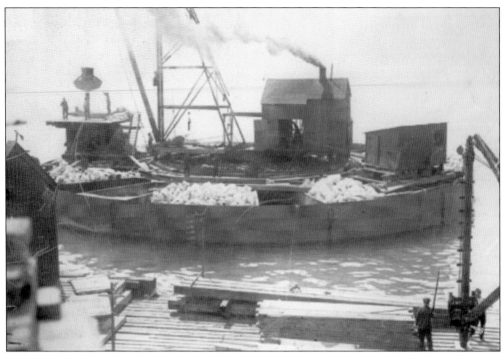

Chicago's water is pumped from Lake Michigan via tunnels that end at water crib buildings, set several miles out into the lake. On January 20, 1909, a sudden explosion and flash fire killed over 50 men building the Sixty-Eighth Street Water Station. There was no hope for escape from the wooden frame structure, except for jumping into the ice-filled lake. The marker below honors 45 unidentified men in a mass grave. Six identified men are also buried here. "Occasionally we have a visitor who is trying to find a family member. We can check the list . . . and guide the person to the mass grave site. . . . this has helped some families bring closure," says Paula Everett. The Underwater Archeological Society of Chicago and Ridge Historical Society hosted a 100th-anniversary program. (Above, courtesy of UASC; below, courtesy of MGCA.)

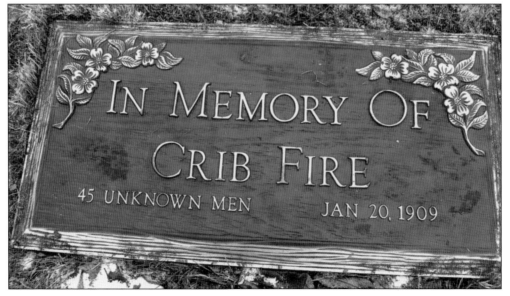

During the Chicago Union Stockyards fire, on December 22–23, 1910, fireman Charles Moore and 23 others were killed when a six-story brick wall collapsed at the Nelson Morris and Company Warehouse No. 7. The men had been hemmed in, with train cars behind them, when the windowless building—which was soaked with hog grease—exploded. (Courtesy of MGCA.)

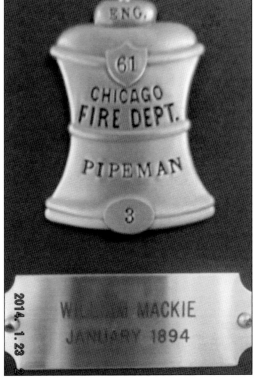

The Columbian Exposition had closed in October, but, on January 8, 1894, a fire roared through the vacant buildings. William Mackie, a fire department pipeman and six-year veteran, fell from a ladder and suffered a broken hip and severe internal injuries. He later died at Mercy Hospital, leaving behind a wife and six children. (Courtesy of Andrea Janota.)

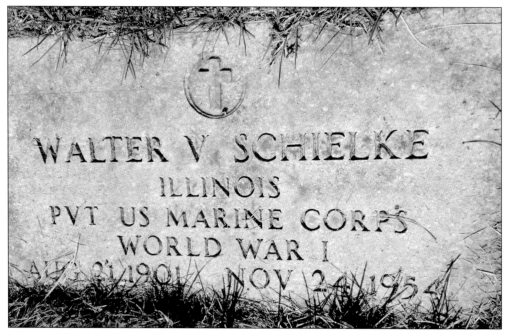

Walter Schielke, a World War I veteran and Chicago fireman, died while manning a hand pump on November 24, 1954. Teenage burglars had broken into the Loring School for Girls—now called Beacon School—at 107th Street and Longwood Drive and set a fire. He died of a heart attack at the scene. (Courtesy of MGCA.)

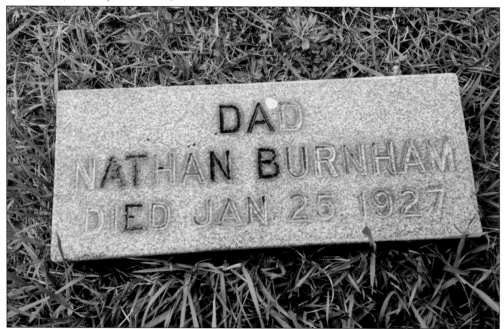

In 1927, Nathan Burnham, a fireman, was injured fighting a house fire on Prairie Avenue. While breaking through a door to rescue a child, Nathan cut his leg with his own ax. This was before antibiotics had been invented, and, at age 46, he died of an infection six days later on January 25, 1927. (Courtesy of MGCA.)

Patrolman Henry A. Mandleco—Star No. 1403—of the 12th Precinct, Kensington District, was shot at 102nd and Halsted Streets on April 23, 1919. He was only 29 years old and had been an officer for two years when he noticed two men in an automobile stealing two crates of live chickens. When he ordered them to stop and drew his gun, he was shot through the heart. (Courtesy of MGCA.)

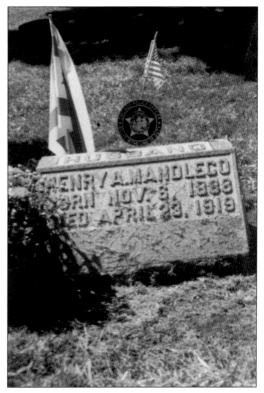

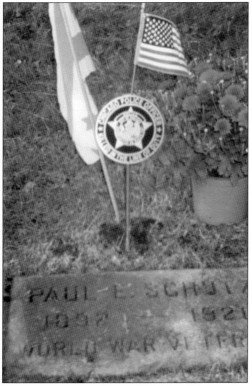

Patrolman Paul Schutz—Star No. 4349—of the 11th Precinct, Englewood District, was killed outside the Galloper's Club, a gentleman's club at 6265 South Western Avenue in 1921. Police had been called to quell a disturbance and were making arrests when they were fired upon by several men in what was believed to be a planned attack. (Courtesy of MGCA.)

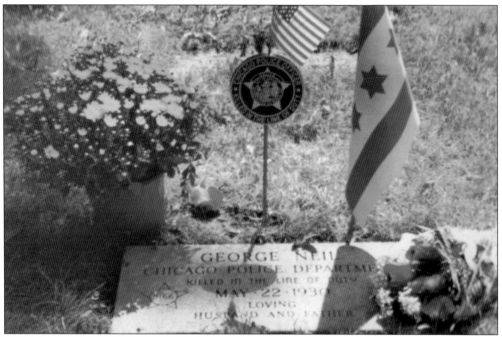

Patrolman George R. Neil—Star No. 5166—of the 18th District, was at a Back of the Yards diner on Halstead Street on May 19, 1930. Four men begin to beat an African American man. Neil identified himself as a Chicago police officer, and the men turned on him, hitting him, throwing a stool, and eventually shooting him in the stomach with his own gun. Four days later Neil, a Bridgeport resident, died. (Courtesy of MGCA.)

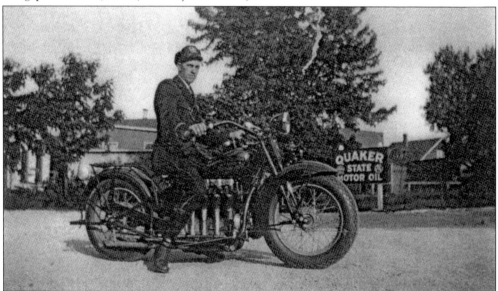

Patrolman for the village of Dolton, Harold Koehncke—Badge No. 2—was murdered in July 1932 when he pulled over four men suspected of armed robbery. He was on a motorcycle but decided to drive the suspects to the station in their car. He was shot in the head four times. The suspects were soon captured in a manhunt by civilians working with Dolton and Calumet City police. (Courtesy of MGCA.)

In September 1981, at a high-rise building in downtown Chicago, six firemen encountered extremely dangerous conditions in a smoke-filled hallway on the 24th floor. One man went missing, and Craig L. McShane—a 17-month rookie from Engine Company No. 42—went back in to find him. Both men accidently fell down an open elevator shaft. The remaining firemen were hospitalized for smoke inhalation and burns. McShane, age 23, had been a lifeguard for the Chicago Park District. The street next to Morgan Park High School, where he went to school, was renamed for him. (Right, courtesy of RHS; below, courtesy of MGCA.)

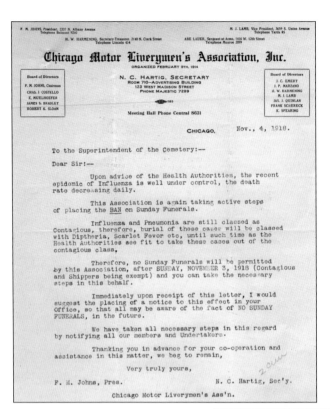

Chicago Motor Liverymen's Association, Inc.

ORGANIZED FEBRUARY 9TH, 1914

Board of Directors

F. M. JOHNS, Chairman
CHAS. J. COSTELLO
E. MUELHOEFER
JAMES S. BRADLEY
ROBERT K. SLOAN

N. C. HARTIG, SECRETARY
ROOM 710—ADVERTISING BUILDING
123 WEST MADISON STREET
PHONE MAJESTIC 7299

Meeting Hall Phone Central 8631

Board of Directors

J. C. EMERY
J. P. MARZANO
H. W. HARMENING
M. J. LAMB
JAS. J. QUINLAN
FRANK SCHERECK
K. SPEARING

CHICAGO, Nov., 4, 1918.

To the Superintendent of the Cemetery:—

Dear Sir:—

Upon advice of the Health Authorities, the recent epidemic of Influenza is well under control, the death rate decreasing daily.

This Association is again taking active steps of placing the BAN on Sunday Funerals.

Influenza and Pneumonia are still classed as Contagious, therefore, burial of these cases will be classed with Diptheria, Scarlet Fever etc, until such time as the Health Authorities see fit to take these cases out of the contagious class.

Therefore, no Sunday Funerals will be permitted by this Association, after SUNDAY, NOVEMBER 3, 1918 (Contagious and Shippers being exempt) and you can take the necessary steps in this behalf.

Immediately upon receipt of this letter, I would suggest the placing of a notice to this effect in your Office, so that all may be aware of the fact of NO SUNDAY FUNERALS, in the future.

We have taken all necessary steps in this regard by notifying all our members and Undertakers.

Thanking you in advance for your co-operation and assistance in this matter, we beg to remain,

Very truly yours,

F. M. Johns, Pres. N. C. Hartig, Sec'y.

Chicago Motor Liverymen's Ass'n.

It is easy to forget that, before the 1950s—when antibiotics, vaccines, and immunizations became commonplace—infections from cuts, injuries, burns, and surgeries killed many people. Diseases such as typhoid fever, diphtheria, tuberculosis, smallpox, scarlet fever, and polio were simply not treatable. In 1918, influenza killed as many as 8,500 people in Chicago, and over 650,000 died in the United States. On October 11, all public funerals were banned, and as many as 1,200 cases of influenza were reported in one day. This November 4 letter states that a ban on funerals will continue. In November 1918, over four times the average number of burials occurred at Mount Greenwood. One victim was 27-year-old Harriet Boelens DeYoung, who left husband Harry and four children. (Above, courtesy of MGCA; right, courtesy of Marla Durbin.)

Jake Teninga was born in Groningen, Holland, and died in Chicago during the Spanish flu epidemic in 1918. A sailor and a carpenter by trade, he was 37 years old and the father of three small children when he died. He met his bride, Alice Smith, at her home in New York when he visited her brother after being honorably discharged from the Navy. After an afternoon of checkers, he bent over, kissed her, and the rest was history. The photograph below, taken in the summer of 1918—just before Jake died—shows the family that he left. From left to right are son Bobby, wife Alice, and daughters Adelaide and Helen. Unfortunately, Bobby died a year later from inflammation around the spinal column after a fall from his uncle's truck. (Both, courtesy of Jill and Robert Eenigenburg.)

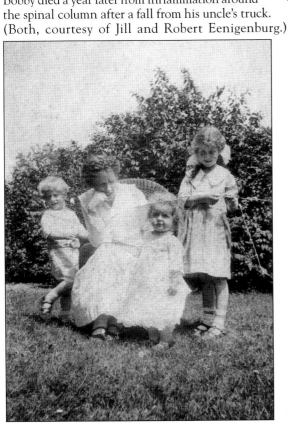

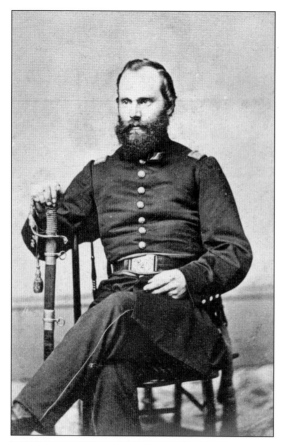

Over 325 Civil War soldiers are buried at Mount Greenwood Cemetery, including Capt. Oscar F. Rudd, who died in July 1864, several weeks after being wounded near Petersburg and Richmond, Virginia. He served as a 1st lieutenant and later as captain of Company G, in the 39th Regiment of the Illinois Volunteer Infantry, which was predominantly comprised of men from the Worth and Palos Townships and the Joliet area. Contemporary accounts and journals of fellow soldiers refer to him as "a most accomplished officer" and "a school teacher from Blue Island, who was well-respected by the men." Today, new Civil War markers honor men such as those below for Pvt. Henry Hotchkiss, Pvt. Frank Farrell, and Pvt. Herman Haney. (Left, courtesy of BIHS; below, courtesy of MGCA.)

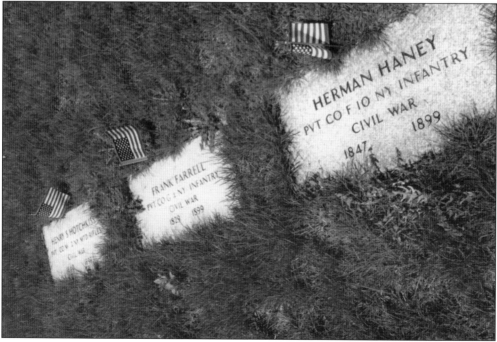

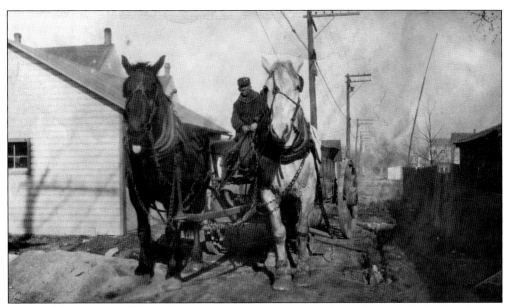

George Felgenhauer, a World War I veteran, worked as a hauler in Morgan Park after the war and never missed a day with his team of horses—as seen here in 1930. Slipping down the hill of 111th Street, with a routine heavy load, one of the horses caught his hoof in the streetcar tracks and had to be put down. George was a kind and benevolent man who was devoted to the Trinity Lutheran Church. (Courtesy of Richard P. Rohloff.)

Cpl. George A. Rohloff of Company H, 132nd Infantry, enlisted in World War I and served two years overseas. He was shot under the heart by machine gun fire on October 9, 1918, during the Muese Argone Offensive, near the border of France and Belgium. Hospitalized for eight months, he was disabled for the rest of his life and died at the age of 49. (Courtesy of Richard P. Rohloff.)

George Rohloff's son Paul (at left) suffered horrendous burns and shrapnel injuries during World War II, when his tank was destroyed by enemy fire in the same region of France and Belgium on September 3, 1944. Paul, a private first class with Company B of the 899th Tank Destroyers, spoke German and was working as a radio communicator in the lead tank when they drove into an ambush. For many years, Paul (left, kneeling) was a science teacher at Mount Greenwood Elementary School on 108th Street and Homan Avenue. He is fondly remembered as an energetic and kindly man who never let his scars, missing fingers, or disabilities hold him back. (Both, courtesy of Richard P. Rohloff.)

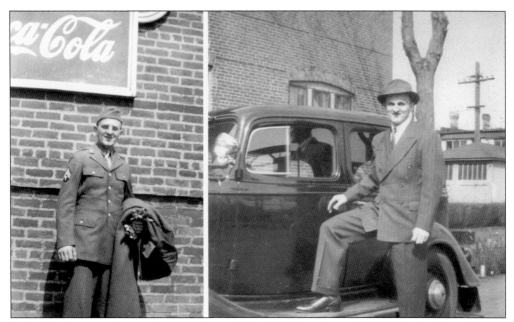

Luka Lukich is seen here posing proudly with his 1934 Chevrolet in 1941. He died in New Guinea, and his body was not returned until 1948. The family saved his car and, in 2003, the automotive technology class at Thornton High School restored the 69-year-old car to pristine condition. The family hopes that it may return to Pullman as a memorial to all their young servicemen. (Courtesy of Judy Rock.)

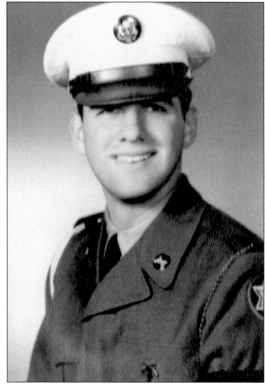

In 1959, Arthur "Buzzy" Beuttenmiller tried out for the Chicago White Sox but then enlisted in the Army when he did not hear back from them. While overseas in Korea, he learned that he had been accepted. He never married but was close friends with the Daley family, who fondly remember their vacations and local adventures with him. He worked as an engineer in the Chicago public school system. (Courtesy of Tom Daley.)

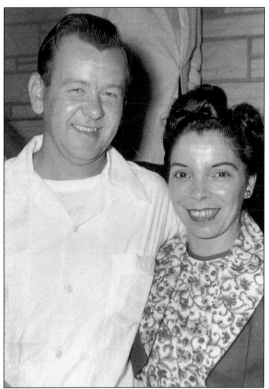

Eugene John Hughes, a Parker High School graduate, was a World War II Army veteran—drafted in 1941—who served in the Philippines and Asia. His wife, Isabelle Gomez Hughes, spoke fluent English, Spanish, Italian, and Polish. Born in 1919, she lived to age 94. (Courtesy of Sandy Hughes Rollberg.)

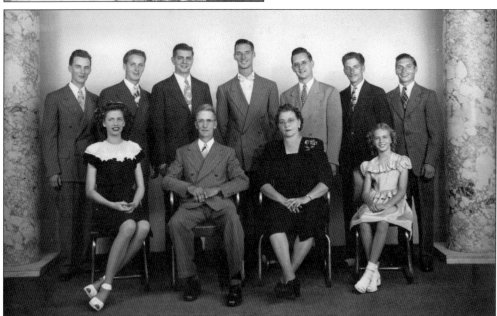

During World War II, the Eenigenburg family was recognized for their five sons, Joe, Ted, Donald, Phillip, and Paul, who were all serving in the military at the same time. Pictured here in 1948 are, from left to right, (first row) Gloria, father Joseph, mother Johanna, and Louise; (second row) Ted, Paul, Robey, Joe, Elton, Donald, and Phillip. Joseph, a roofing contractor, and Johanna, born in Orange City, Iowa, married in 1913. (Courtesy of Jill and Robert Eenigenburg.)

During World War II, Maj. Thomas B. Mackie was posted in Australia with US Army Intelligence. They broke the Japanese intelligence code just prior to the campaigns in New Guinea and the South Pacific. Later, he worked as a divorce and probate lawyer in Chicago. (Courtesy of Andrea Janota.)

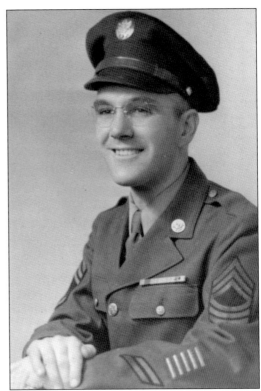

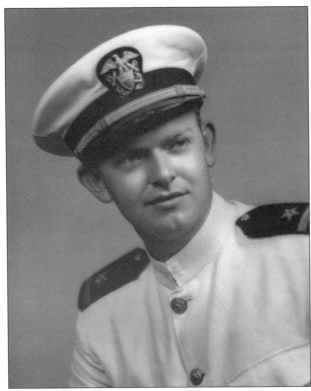

Lt. (jg) Delbert Zeigler graduated from the Illinois Institute of Technology with a mechanical engineering degree and worked for Pullman Car Company before enlisting in the Navy. He died in a vehicle accident shortly after the cessation of hostilities. Initially buried on Okinawa in 1945, he was re-interred at Mount Greenwood with full military honors in April 1949. (Courtesy of Patty Robinson.)

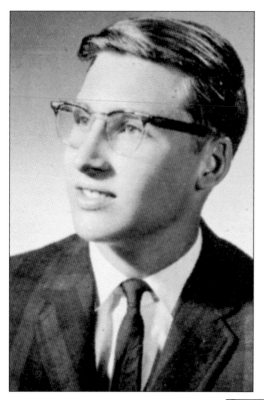

Larry Dart, a Mount Greenwood local, was a popular baseball player and singer who played four instruments. A graduate of Morgan Park High School and Drake University, he was enrolled in Drake Law School until he lost his draft deferment. Rather than serve in the infantry, he enlisted and served as a combat engineer in the 65th Engineers, C Company, 25th Infantry Division. Awarded the Silver Cross for rescuing several men from a burning armored personnel carrier, he was injured two weeks later by a booby-trapped barrel. He died a week later, in 1969, and was awarded a Purple Heart. Today, he is honored on the Vietnam Veterans Memorial Wall in Washington, DC. This war, like so many others, made heroes of those with talents and skills, such that their loss is even more poignant. (Left, courtesy of James Dart; below, courtesy of MGCA.)

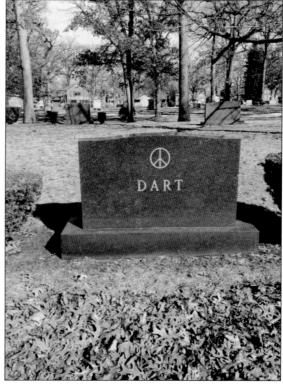

Five

WORKING TOGETHER, DOING OUR PART

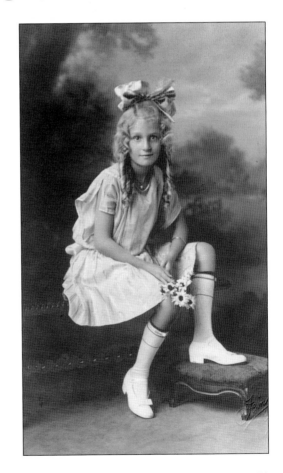

The Edna White Memorial Garden on 111th Street, at Esmond Street and next to the Morgan Park Police Station, honors this kind-hearted educator and community advocate. Shown here as a young girl in the early 1920s, Edna Dickson taught in Oak Lawn and was active in many community organizations. Her memorial garden has evolved into an Illinois prairie garden, maintained by the Morgan Park Junior Woman's Club. (Courtesy of RHS.)

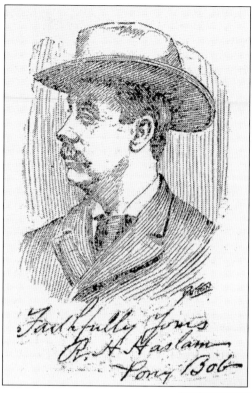

Robert H. Haslam, "Pony Bob," emigrated from London. The Virginia City 1860 US Census reads "Robert Hashlam, occupation Pony Express Rider." Abraham Lincoln's inaugural address, of keen interest in helping California decide whether to stay with the Union, was carried by Bob for 120 miles at record pace despite being seriously wounded by Indian arrows. Bob was a courier for Wells Fargo, a US Army scout, a federal marshal in Salt Lake City, in Buffalo Bill Cody's Wild West Show, and later, at Chicago's Congress Hotel, entertained guests with his life's adventures. Sadly, after a debilitating stroke, he died in deep poverty on the fifth floor of a coldwater flat. Below are, from left to right (first row) John Colton, Alexander Majors, and W.F. Cody; (second row) R.H. Haslam and Prentiss Ingraham. (Left, courtesy of Russell Spreeman; below, courtesy of BBCW.)

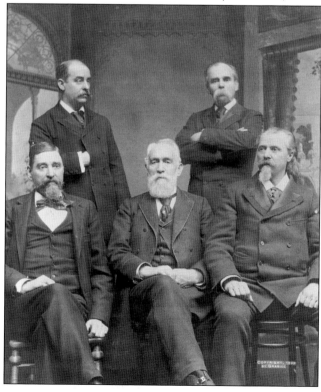

Often assumed to be an Irish ballad, "I'll Take You Home Again Kathleen" was actually written in 1875 by Thomas P. Westendorf—a music teacher in Plainfield, Indiana—for his wife, Jennie Morrow. It was intended as a reply to "Barney, Take Me Home Again." Because of his fame, he could have worked anywhere but chose to be a music teacher and superintendent at houses for refugees and reform schools for juvenile offenders in Chicago, Indiana, Kentucky, and Tennessee. He was described in the *Potters American Monthly* as "pleasant and agreeable . . . of cheerful disposition, a countenance beaming with benignity, and yet a strict disciplinarian; just such a man would be most called to success." A prolific composer, over 40 of his songs, instrumentals, and dance music had been published by 1880. His marker reads, "He wrote that others might sing." (Both, courtesy of MGCA.)

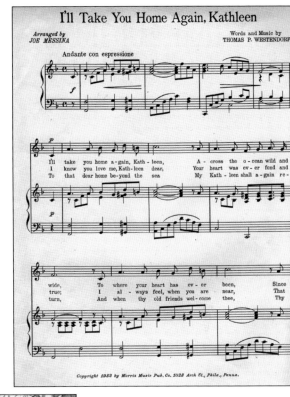

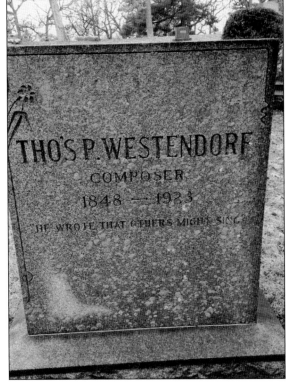

Alice DeWolf Kellogg Tyler was an instructor at the Art Institute of Chicago, educated in Paris art schools, a Society of American Artists member, and the recipient of numerous honors. Her *Portrait of Miss G.E.K.* was at the 1889 Exposition Universelle in Paris—for which the Eiffel Tower was built. Her work also appeared in the 1893 World's Fair, and her famous oil painting, *The Mother*, is at Hull House. Sadly, Alice died at age 37 from complications associated with diabetes. She is buried with her husband and their infant child. Jane Addams gave her eulogy. The sculptor Lorado Taft wrote that "she fairly radiated light and helpful cheer. . . . To me she seemed almost an ideal artist—the soul of art personified. In her frank, zestful love of her work, of nature, of life, there was something rare and exalted." (Both, courtesy of JoAnne Bowie.)

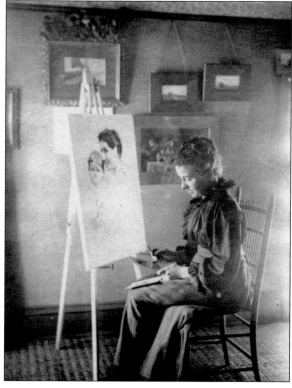

John Vanderpoel's book *The Human Figure* was first published in 1907 and is still in print. With over 430 drawings of the minute details of eyes, arms, feet, and more, it was based on the classes that he taught for 30 years at the Art Institute of Chicago. Awarded many honors and active in art societies, he has been given credit by many students—including Georgia O'Keeffe. His sister Matilda, who founded the children's Saturday classes, was also an instructor at the Art Institute for many years and was buried near him in 1950. His sudden death prompted artists to donate their works in 1914, establishing the community's Vanderpoel Art Collection. The Vanderpoel School is also named for him. (Right, courtesy of Sidney C. Hamper of the John H. Vanderpoel Art Gallery; below, courtesy of RHS.)

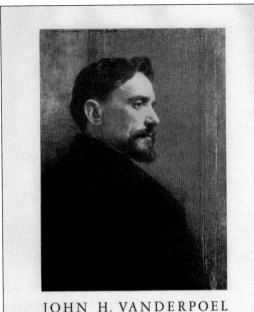

JOHN H. VANDERPOEL

PORTRAIT BY SAMANTHA LITTLEFIELD HUNTLEY

The original oil, of which this is a photograph, may be seen hanging in the Vanderpoel Art Gallery, Chicago, Ninety-Sixth Street and Longwood Drive

THE HUMAN FIGURE

John H. Vanderpoel

LIFE DRAWING FOR ARTISTS

April 17, 1916.

Willis N. Rudd, Esq., Superintendent,
Mt. Greenwood Cemetery,
Morgan Park,
Chicago, Ill.

Dear Sir:

Piccirilli Brothers of 467 East 142nd Street, New York, are shipping to your care the stone which is to be placed over my brother's grave. I enclose a drawing showing the dimensions of the stone and the level at which it is to be set. I assume that you have regulations in regard to the foundations and that no instructions need be given in this regard.

I should be indebted to you if you would kindly let me hear from you upon receipt of the stone.

Yours very truly,

Daniel C. French.

DCF/EEH

William M.R. French, the first director of the Art Institute of Chicago, was also in charge of the operations at the art school. William's massive grave marker (below) was designed by his brother, Daniel Chester French—who also sculpted the Lincoln Memorial in Washington, DC. A Civil War veteran from Massachusetts and a Harvard graduate, he was initially a civil engineer and landscape designer who later lectured nationally on art. He and his wife, artist Anne Helm, lived in North Beverly. He was also founder and president of the American Association of Museums. (Both, courtesy of MGCA.)

Emma Graefen Benck was a skilled hat maker and artist. Her family retains many postcards of her work for Marshall Field and Company. Unfortunately, in 1914, she fell ill from a burst appendix at age 28, leaving behind a 16-month-old son and husband. The antibiotics that might have saved both her and her father—who died when she was four—would not be commonplace until the 1950s. (Courtesy of Linda Jensen.)

Helen Koch, a PhD from Blue Island, was a University of Chicago professor of child and educational psychology. In the 1930s, she dispelled the theory that orphans were innately mentally deficient—compared to middle class children—by educating orphans in preschools for six months. Their scores dramatically improved. Orphanages have since disappeared, and the Head Start Program began in 1965. Her book *Twins and Twin Relations* details another of her research interests. (Courtesy of U of C.)

Kate Starr Kellogg is best known in the Beverly area as a distinguished and innovative educator who was one of the first women principals in the Chicago school system. She was also a musician and composed wedding music during the 1893 World's Fair as a member of the World's Congress of Representative Women. In 1895, she was principal of the Lewis-Champlin School in Englewood, at Sixty-Fifth Street and Stewart Avenue. The Kellogg Elementary School on Leavitt Street is named for her. Her grave, like several others on her family plot, is not marked with a stone. (Both, courtesy of JoAnne Bowie.)

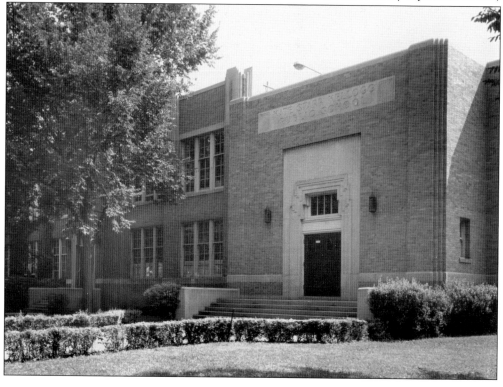

Alice Barnard is one of the most famous educators in Chicago's history. Her family moved to the city in 1848. She taught for many years at the Dearborn School in downtown Chicago. A pioneer in women's rights, she was offered the position of principal at a salary of $1,200 but refused because a man would have been paid $1,000 more. In 1876, she agreed to serve as principal of the Jones School and was one of the first women principals in Chicago. She was consistently praised for her innovations, strength, and influence. She created an ungraded curriculum for special needs children and supported the education of black children. She retired in 1891, and shortly after, the old Washington Heights School at 103rd and Charles Streets was renamed the Alice L. Barnard School. It is shown below in about 1904. (Both, courtesy of RHS.)

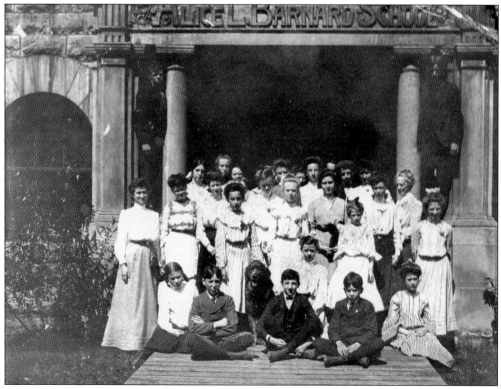

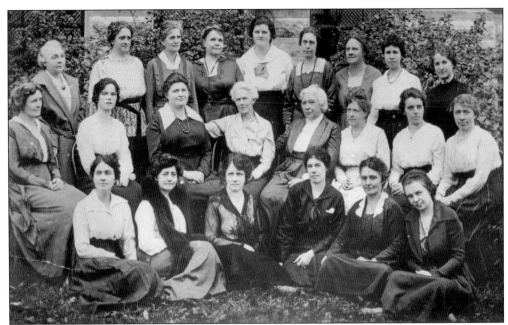

Born in Blue Island, Elizabeth Huntington was a local girl who—for 39 years, beginning in 1883—was the principal at the new Barnard School. She waited until age 43 to marry David Sutherland, as marriage was frowned upon for working women. Educated at the Cook County Normal School, she taught in Hyde Park, Blue Island, and Mount Greenwood schools. An innovative educator, she established a kindergarten and other progressive initiatives. Her obituary says that she was "beloved by everybody . . . sympathetic, kind, thoughtful, considerate." She is seen at the center of the group photograph above, with her fellow faculty members. After she died in 1924, the new Sutherland School was named for her. She did not have children, though numerous family members are buried in her lot. Oddly no stone marks her grave. (Both, courtesy of RHS.)

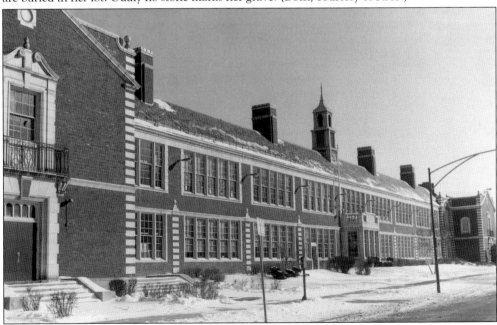

Born in Stoud, England, Henry Rowland Clissold's parents originally settled in Canada, but he was a printer in Chicago for 67 years. He founded Clissold Printing and the Bakers' Helper Company and published works by William Rainey Harper, served in numerous leadership roles in the Baptist Association, helped form the National Association of Master Bakers, and was president of Chicago Trade Press Association. He was also a leader in his community, serving as a Village of Morgan Park trustee, on the board of the Calumet Trust and Savings Bank (the building where BAPA is now located), and on the Sunday School Board of the Morgan Park Baptist Church. He died in 1930 at age 87. The Clissold School, built in 1931, was named for this energetic, community-oriented man. (Both, courtesy of MGCA.)

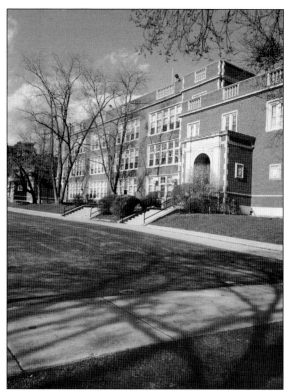

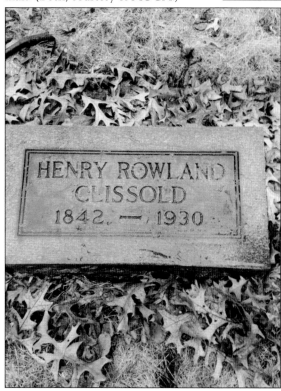

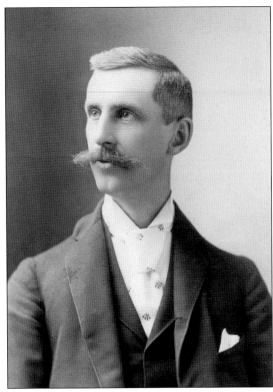

For 59 years, families relied on Dr. William German at 10924 South Prospect Avenue. Moving to Morgan Park in 1884, he was also the surgeon for the Chicago, Rock Island & Pacific Railroad. He was a board member with School District 131 when Esmond School (below)—the area's first public school—was built. He was secretary of the Calumet Park District and missed only one meeting during the entire 27 years that it existed before it merged with the City of Chicago Park District. The son and grandson of Methodist ministers, he was a charter member and helped build the Morgan Park Methodist Church. (Both, courtesy of RHS.)

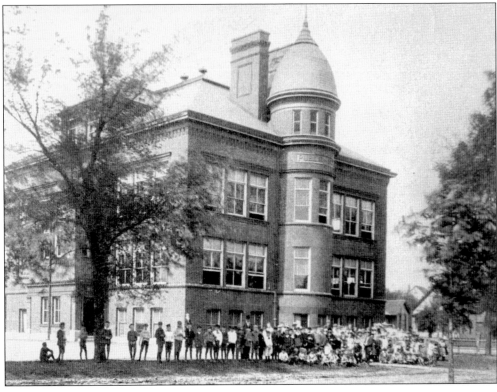

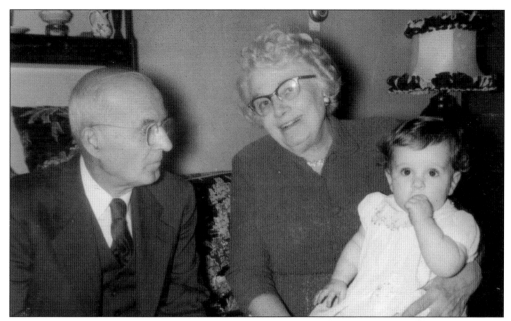

Henry Launspach is shown above with his wife, Harriet Faucher, and granddaughter, Paula. Harriet's parents immigrated from Alsace-Lorraine, France, to a homestead in Oklahoma—when it was still Indian Territory. There, Harriet was kidnapped, but her father, a butcher, ransomed her back in exchange for cow's blood and the family moved to Chicago. She married a pharmacist, Henry, in 1916, and they purchased the Monterey Pharmacy on 111th Street—near the post office in Morgan Park—in 1924. The pharmacy had a soda fountain and was a well-known gathering place. The Launspachs operated this family business for over 40 years, until 1972. They had three daughters, including a set of twins. (Both, courtesy of Klenk family.)

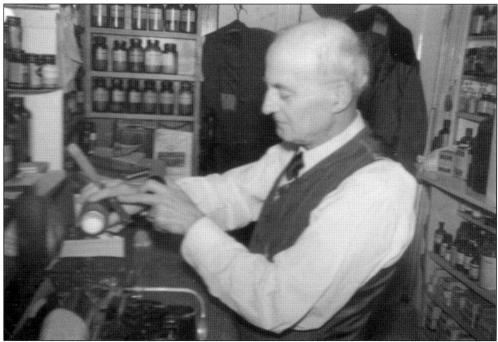

Margaret A. Coffey, PhD, from the University of Massachusetts at Amherst, was a well-known sports educator and proponent. One article, "Then and Now a Sportswoman," describes how women, their dress (long dresses and corsets), and their interests changed between 1900 and the 1960s. She lived to see Title IX of the US Education Amendments of 1972, which gave women the right to university athletic scholarships—something that is now taken for granted. (Courtesy of Klenk family.)

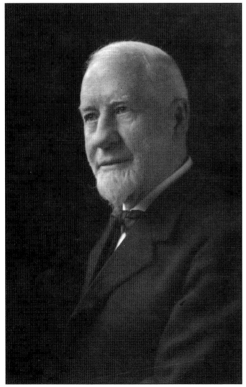

Thomas Wakefield Goodspeed was village president of Morgan Park and secretary of the Morgan Park Union Theological Seminary (now Morgan Park Academy). Along with John Rockefeller, he raised over one million dollars to build the University of Chicago and served on the school's board of trustees for 30 years. He wrote a biography of William Rainey Harper and the history of the university, where his papers are archived. (Courtesy of U of C.)

"Professor" George A. Brennan was, for 50 years, a well-respected historian and educator in Fernwood and Roseland. He was active in the Chicago Historical Society, the Prairie Club of Chicago, and numerous civic groups. He made drawings of local fossils and Native American artifacts. He also wrote about the Lake Michigan dunes and the books *History of Chicago-Calumet Region* and *The Dutch in America*. (Courtesy CPL-HW.)

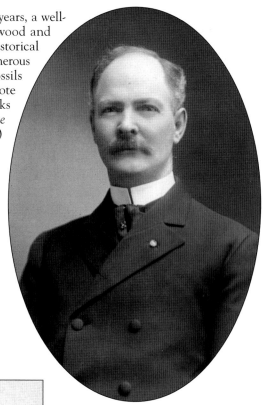

SOUTHERN COOK COUNTY

AND

HISTORY OF BLUE ISLAND

BEFORE THE CIVIL WAR

BY

FERDINAND SCHAPPER

of Blue Island, Illinois

And Presented by Him to the
Chicago Historical Society

1917

VOLUME I (Part 1)

Anyone with ties to early settlers and families in the southern Cook County area has reason to thank another Blue Islander—Ferdinand E. Schapper. In 1917, he hand-typed a three-volume opus, *Southern Cook County and the History of Blue Island before the Civil War*, that was compiled from interviews, notes, and sales records from the drugstore owned by him and his father. (Courtesy of SSGHS.)

Henry R. Koopman's photographs, postcard photographs, and reminiscences document 50 years of Pullman, Roseland, Fernwood, Kensington, and Morgan Park history—from the 1870s to 1944. His Leader Studio at 111th Street and Michigan Avenue did the usual wedding, birth, graduation, confirmation, and family portraits, but he also photographed parades and street scenes as the towns grew. (Courtesy CPL-HW.)

DOWN AN INDIAN TRAIL IN 1849

THE STORY OF ROSELAND

by Marie K. Rowlands

Taken from the Roseland, Illinois Centennial Issue of the

CALUMET INDEX, Monday, June 20, 1949

Permission granted for reprinting

Reprinted for

the Dutch Heritage Center
TRINITY CHRISTIAN COLLEGE
Palos Heights, Illinois

The Dutch Heritage Committee is especially grateful to two individuals without whose support this project would have been impossible: Mr. N. Paul Sood graciously granted us permission to reprint the story to which he holds the copyright. Future readers will be forever indebted to his goodwill in releasing this tale from the files of the Calumet Index. The story will now be read again and again.

Mr. Martin Ozinga Jr., through his association with the First National Bank of Evergreen Park, Illinois, the Clearing Bank in Chicago, Illinois, and the Oak Lawn National Bank in Oak Lawn, Illinois, generously arranged for adequate funding which put this project within the realm of financial feasibility. His generosity and interest in the activities of the Dutch Heritage Center are much appreciated.

Local historian Marie K. Rowlands, the daughter of Henry R. Koopman, interviewed many families and old-timers for the Calumet Historical Society. Her book, *Down an Indian Trail: The Story of Roseland*—taken from the centennial issue of the *Calumet Index* and published in 1949—is an invaluable family history tool that provides insight into life in early Chicago. (Courtesy of SSGHS.)

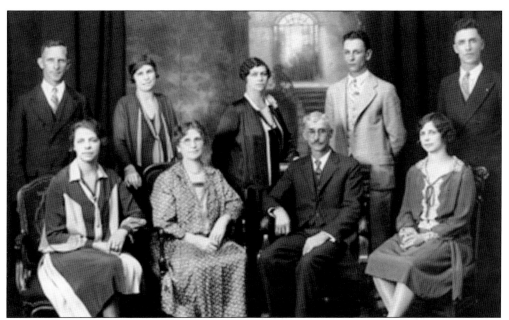

Harry Eenigenburg Sr., son of first settler of Roseland, homesteaded in South Dakota and married Louisa Phillips. He returned to build many Roseland buildings, wrote *The Calumet Region and Its Early Settlers*, and was building chairman of Bethany Reformed Church. Pictured in 1920s are, from left to right, (first row) Josephine, Louisa, Harry Sr., and Mabel; (second row) Gerrit, Lou, Jennie, Harry Jr., and Joseph. (Courtesy of Jill Eenigenburg.)

For 56 years, beginning at age 14, John Volp worked in publishing. He formed the Blue Island Publishing Company and the Associated Suburban Publications, whose *Sun*, *Standard*, and *Star* newspapers covered most of the area. His book, *Story of Blue Island*—which was written for the Blue Island Centennial in 1936—is another classic of local history. His death was a loss for the whole community. (Courtesy of SSGHS.)

THE FIRST

HUNDRED YEARS

1835 — 1935

HISTORICAL REVIEW
of
BLUE ISLAND, ILLINOIS

WRITTEN AND COMPILED BY
JOHN H. VOLP
BLUE ISLAND, ILLINOIS

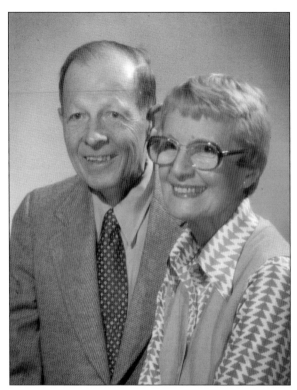

Self-trained historians like Robert "Bob" White are the backbone of local history centers. He worked for the Hammond Organ Company for 40 years and was instrumental in founding the Ridge Historical Society in 1971, serving as its first president. He was the society historian until 1988 and provided numerous history talks and slide presentations. He wrote many articles for the *Beverly Review* and *Villager* newspapers and researched details that led to the 1976 establishment of the Ridge Historic District, which includes 3,000 buildings. He and wife Edna did not have any children, so their papers, photographs, and objects from the "early days" of both the Dickson and White families are retained at the museum. The Edna White Memorial Garden, next to the 111th Street police station, was named for his wife. (Left, courtesy of MGCA; below, courtesy of RHS.)

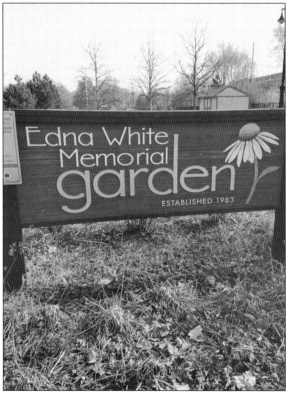

Six

IMMIGRANTS AND
THEIR SUCCESSES

Six branches of the Hoekstra family immigrated in the 1880s. For generations, they were farmers in the Frisian village of Ee. In Pullman, Roseland, and South Holland, the families prospered though hard work as truck farmers, ministers, and at the Pullman Car Works. This July 4, 1935, gathering was at William Hoekstra's farm in South Holland. Over 65 individuals named Hoekstra are buried at Mount Greenwood. (Courtesy of Robert P. Swierenga.)

Alfred Grayston (left) came to Canada from England. His wife, Mary Ann, was an orphan sent from England to help populate Canada. They moved to Chicago, where their son Henry married Elsie Schallman (below, right). Henry was a pioneer pilot who took many people on their first airplane ride at Harlem Avenue Field on Eighty-Seventh Street. Elsie Schallman played accompanying piano for silent movies and vaudeville shows at the Roseland State Theater at 110th Street and Michigan Avenue, where she met Henry, who was the movie operator. During World War II, Henry served in the Civil Air Patrol. (Both, courtesy of Lois Grayston.)

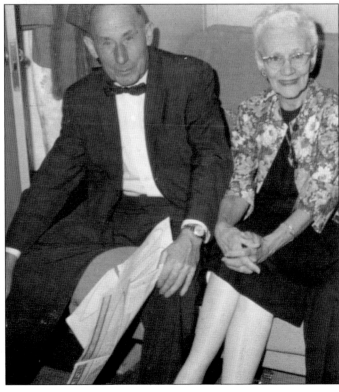

Little Harold "Buddy" Grayston (right), son of Henry and Elsie, died of appendicitis at age four and a half in 1921. His grandparents August and Emily Schallman had two daughters (below), Elsie Schallman Grayston (right) and Vi Schallman Redman (left). August met his wife, Emily, in Germany, and she would only marry him if they moved to America. August worked for Pullman from age 20 until he retired. (Both, courtesy of Lois Grayston.)

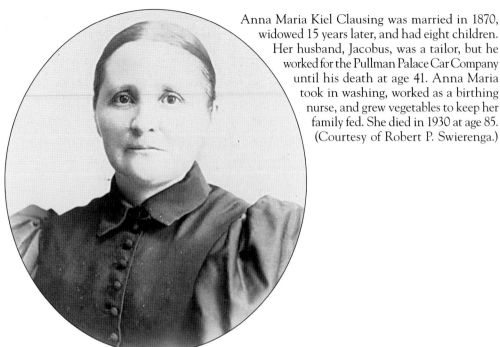

Anna Maria Kiel Clausing was married in 1870, widowed 15 years later, and had eight children. Her husband, Jacobus, was a tailor, but he worked for the Pullman Palace Car Company until his death at age 41. Anna Maria took in washing, worked as a birthing nurse, and grew vegetables to keep her family fed. She died in 1930 at age 85. (Courtesy of Robert P. Swierenga.)

This photograph of the Sprietsma family was taken in Roseland in the late 1910s. They are, from left to right, (first row) Kate (Wibalda); mother Agnes (Dekker); father Lucas; Anne (Renkema); and Rose (Blokker); (second row) sons George, William, Henry, Charles, Richard, John, and Jacob. Most are buried in Mount Greenwood, along with spouses, children, and grandchildren. (Courtesy of Laurie Coolidge.)

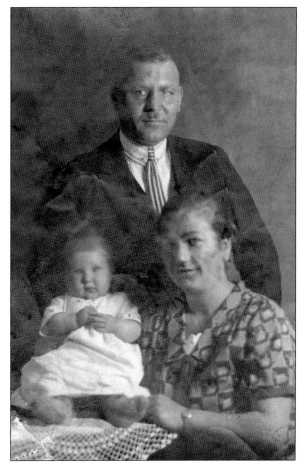

Baby Annaliese, Hugo, and Lisa Frese Priedigkeit rapidly emigrated from Germany as Adolph Hitler's impact grew, as Hugo had been one of the policemen who arrested and jailed Adolph Hitler in 1923—after the Ruhr Uprising. Hugo had served in the German army during World War I, was exposed to mustard gas, and was wounded four times. He was awarded Germany's Iron Cross. Hugo's father, Adolph, had been an equestrian palace guard for Kaiser Wilhelm, but he and his wife, Anna, also immigrated to America when Hitler came to power. (Both, courtesy of Barbara Lange Trubac and Claudine and Wally Liesinger.)

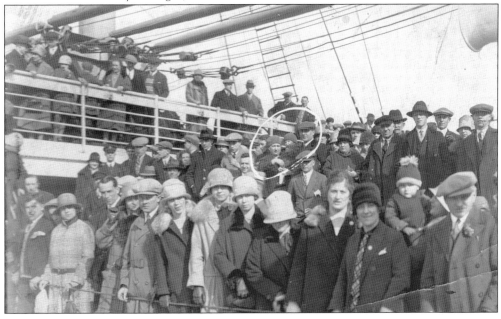

Anna Bucher, born in 1843, emigrated from Zurich, Switzerland. When her first husband, Soloman Hirt, passed away in 1874, she ran a boardinghouse to support their three children. Her second husband, John Maher, was a molder in the iron business, and together, they had three more children. She was a devoted Presbyterian described in her obituary as "an earnest Christian worker." (Courtesy of Mary Ann Boggs.)

Matthew Gomez was born in Spain in 1900 but was abducted at age five and forced to go to sea as a cabin boy. He jumped ship in Cuba at age nine, worked in the sugar cane fields, made his way to New York at age 14, and then came to Chicago. With his wife, Mamie, he operated the popular Mamie's Restaurant in Englewood until his death in 1962. (Courtesy of Sandy Hughes Rollberg.)

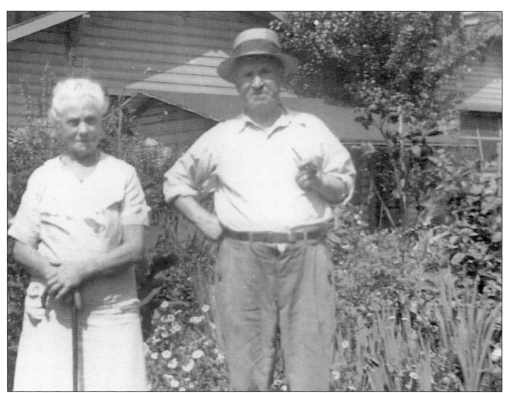

Sarah Yates and Samuel Geddes stand together in their garden in the above photograph. Married in 1882, they were emigrants from the Manchester area of England. He worked for the Pullman Car Works Company for 42 years, as did several of their eight children. One daughter, Mabel Jane, was born with genetic, short-limbed dwarfism. Although she died at age 29, she survived longer than the doctors had expected. She graduated from school and was remembered as very intelligent, kind, and thoughtful. One of their sons was William "Bill" E., who married May Dixon in 1905 and had a son, William R.A. The elder Bill left school at grade six to work at the Pullman Car Works Company for 18 years before moving to the General American Transportation Corporation (GATX) for 27 years and retiring in 1948. (Both, courtesy of Joyce Beedie.)

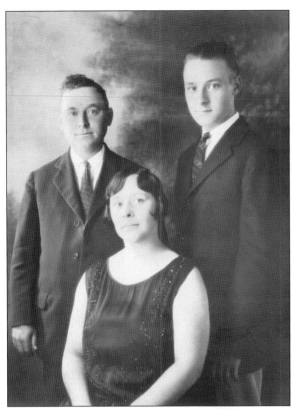

William R.A. Geddes played football at Purdue University and married Mary Mabel "Mibs" Emerson (below), of Saskatchewan, Canada. As a child, she had learned proper etiquette—including how to curtsy—in case she met the Queen of England. An active woman, she was on the girls' basketball team, ran track, ice-skated, bowled, and played the saxophone. In 1929, she moved to Chicago to attend nursing school, but the Depression changed her plans. During this period, Mibs worked as a copy editor for Conkey Printing and for the Sherwin-Williams Paint Company. She loved ballroom and square dancing and, after retirement, she volunteered with special needs adults and children at local square dancing clubs. She died at age 87. Most of Bill's career was at GATX—where his father had also worked—and he retired as the company's chief estimator. He was also an avid ham radio operator. (Both, courtesy of Joyce Beedie.)

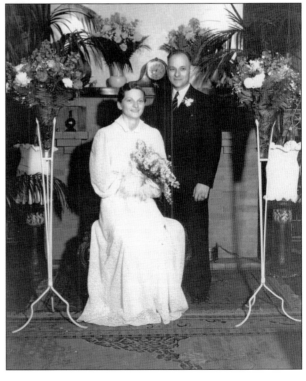

Marion "Mae" Mackie and Charles Imrie—who had emigrated from Scotland—were the parents of four daughters, the oldest of whom was seven years old when Mae died suddenly. Charles was a mailman in Chicago. With the help of his church and extended family, he was able to keep and take care of his daughters—unlike many families of that era whose the children were sent to orphanages. Two of his daughters, Ruth Imrie (Mrs. Matthew) Foertsch (left) and Edith Imrie (Mrs. George) McCallister, are seen below in 1955 wearing mink stoles. (Both, courtesy of Barb Marzillo.)

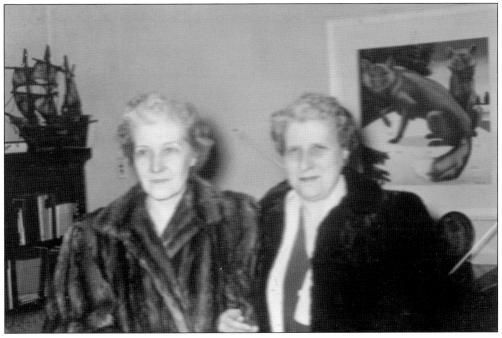

Samuel and Mary Herman Krug emigrated from Austria in about 1903. Samuel worked for the railroads. Later, most of their children lived near Talman Avenue, in a close-knit neighborhood. Weekend family parties were filled with card games, laughter, and singing around the piano. One of their daughters, Mary, married Charles Polivka. Charles was a foreman at the J.B. Pearson & Co. printing firm. After their children started grammar school, Mary worked for many years at the Seward School. Numerous Krugs and their relatives are buried at Mount Greenwood, along with Evangelical Lutheran Church members from the Talman area. (Both, courtesy of Bonnie Polivka.)

Kathryn Stein Gatter emigrated with her first husband, Carl, from Danzig, Germany, in 1892. Carl was a carpenter. They were naturalized in 1897, and by 1910, they owned their own home. Both are buried at Mount Greenwood. When Carl died in 1920—at age 56—Kathryn remarried. She was very involved in her church and community and is remembered fondly by her family. (Both, courtesy of Herman Schell.)

Jan "John" Ton and Aagie VanderSyde—accompanied by her parents—immigrated in 1849. They were married in 1853 and had 14 children who lived to adulthood. Their farm in Riverdale was said to be a stop on the Underground Railroad. They are one of the "founding families" of Roseland, and most of Jan's siblings also immigrated here. A memorial (below) at the First Reformed Church in South Holland commemorates the family. Jan died in 1896, and, for the next 60 years, the family held the Ton Family Reunion, which was highlighted in an article in *Life* magazine in September 1945. (Left, courtesy of Patty Robinson; below, courtesy of Jill and Robert Eenigenburg.)

Cornelius H. Ton and his family are pictured here, from left to right: Mabel (Kroop); Cornelius; his wife Pieterje "Nellie" Tanis Ton; and their daughter, Jennie (VanderMey). Cornelius's father, Harmen Ton, was another founding citizen of Roseland. Harmen was a sailor in the Netherlands until he and wife, Maartje Blom, immigrated in 1865 with their three earliest children. The 1900 census shows that only six of their 13 children lived to that period. (Courtesy of Patty Robinson.)

Jacob DeJong may have had several thousand dollars of gold in his money belt when he immigrated in the 1840s. He married Geertje Eenigenburg, and 11 of their children were born in Holland and five more in Roseland. Only six survived to adulthood, and three of their children died at sea. Jacob died in 1875, was buried at the First Reformed Church, and is one of the many re-interred at Mount Greenwood Cemetery. (Courtesy of Glen DeYoung.)

The Kingma family is seen above in 1898. They are, from left to right, (first row) Anne (Dekker); mother Dettje "Dora" Kamstra, Dora Vis, father Ulbe, and Nellie, holding baby Albert; (second row) sons Jan "John," Joseph, and Richard. Ulbe, shortly after emigrating from Holland in 1880, had his right arm partially amputated due to an infection from an accident at the Pullman Palace Car Company. His wife, Dora, went door-to-door with a pack selling fabrics and sewing notions until they were able to purchase property and built a store and home. As Ulbe's heath declined, his son Jan—shown below standing in front of his horse-drawn buggy advertising "dry goods, notions and shoes"—helped his mother. Jan died in the 1918 influenza pandemic, leaving behind a family of six. Dora died suddenly in a fall down the stairs one night. (Both, courtesy of Glen DeYoung.)

Desanka Lukich, born in Yugoslavia, operated a corner store at her home. She had the first telephone in the area and made it available for neighbors to use. She was the neighborhood "helper," as people would often stop in and cry out, "Mrs. Lukich, got problem, please help." Her husband, Milosav, was born in Serbia and worked both at the Pullman factory and part-time at Mount Greenwood Cemetery. The Lukich family is seen here in 1927. They are, from left to right, Emilia, Desanka, Violet, Milosav, and Luka. (Courtesy of Judy Rock.)

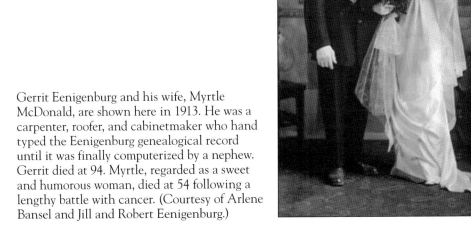

Gerrit Eenigenburg and his wife, Myrtle McDonald, are shown here in 1913. He was a carpenter, roofer, and cabinetmaker who hand typed the Eenigenburg genealogical record until it was finally computerized by a nephew. Gerrit died at 94. Myrtle, regarded as a sweet and humorous woman, died at 54 following a lengthy battle with cancer. (Courtesy of Arlene Bansel and Jill and Robert Eenigenburg.)

Pictured here in the late 1800s, siblings (left to right) Albert, Catherine, John, and Charles immigrated to Roseland with their parents, Klaas and Grietje Kleinhuizen. John was part owner of the well-known Kleinhuizen & DeYoung Lumber Mill. Kleinhuizen and Company Contractors built the First Reformed Church of Roseland, as well as many other buildings in the area. (Courtesy of Glen DeYoung.)

Renze VanderMey was born in the Friesland province of the Netherlands, in the small town of St. Annaparochie. He married Margaret Kuipers shortly before immigrating to the United States in 1882. They had a truck farm at Seventy-Ninth and State Streets, where the vegetables they grew were trucked into the city and sold. Pictured from left to right are Renze, unidentified, Jennie, Margaret, Hattie, and Herman, with Richard sitting on the wagon. (Courtesy of Patty Robinson.)

Seven

FAMILIES OF MOUNT GREENWOOD

The Barnard, Wilcox, Graham, Howe, and Bebb families were well-known early settlers, businessmen, and educators in the Beverly area. Together, they had a successful seed business and extensive land holdings, fruit orchards, and farmlands. St. Barnabas School is now located on this property. Many Barnard family papers, objects, and books are available for research at Ridge Historical Society. (Courtesy of RHS.)

Many recognize the name Aggen for being the family behind the "Last Farm in the City of Chicago." In 1891, they moved to a farm, rented from the school district, on 111th Street. Pictured above in 1887 are, from left to right, (first row) baby Steffen, mother Antonetta Dijkema, Mano, Render, Antje "Annie," and father Jacob; (second row) Stientje "Stena" and Jan "John." Family records from the 1910s and 1920s tell of fields of sugar beets, radishes, cabbages, wheat, strawberries, corn cabbages, and lettuce where the Chicago High School for Agricultural Sciences—which opened in 1985—is now located on 72 acres, of which 40 acres are an experimental farm. The school teaches agricultural sciences to students from an urban setting. (Above, courtesy of Glen DeYoung; below, courtesy of MMK.)

Pictured here in 1912, Jacob (left) and his brother Steffen stand in front of their barns, while grandbaby Jeanette Aggen (Buikema) and their dog Spotty can be seen in front of them. Long before farmers' markets and the push for locally grown produce were common, Aggen's Farm Stand was highly successful, as the below 1967 photograph shows. The Mount Greenwood neighborhood fiercely fought the farm's forced foreclosure by the Chicago School District in the 1980s. (Both, courtesy of Glen DeYoung.)

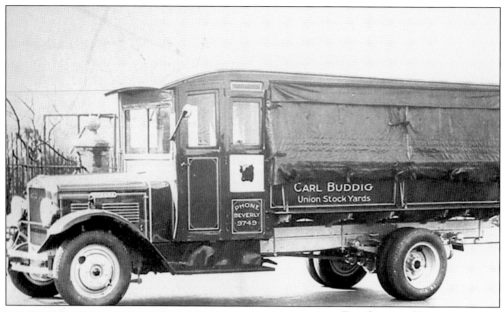

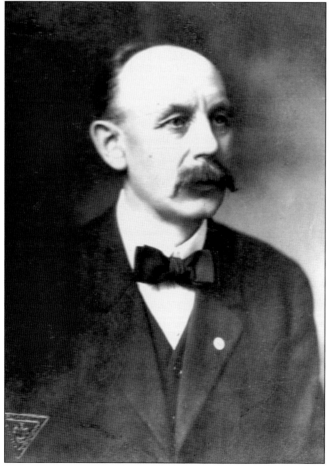

Family-owned businesses continue to thrive in the Chicago area. Carl Buddig & Company (above) is a family-owned business for four generations and one of the oldest meatpacking and distribution companies in the Chicago area. In 1890, John Buddig (left) owned a small butcher shop where his son, Carl, worked. But Carl had bigger plans. He opened his own wholesale meat distribution company, serving small grocery stores and meat markets throughout northern Illinois. In that era, dried beef was one of the company's most popular items as it standardized production and produced a consistent, high quality product compared to its competitors. In the 1950s, large supermarkets replaced small local shops, so Carl's company developed a type of innovative vacuum-packed packaging to guarantee high quality and consistent weight. (Both, courtesy of Thomas R. Buddig.)

From a small plant on the south side in 1957 to a much larger processing facility in South Holland, this family-owned business has continued to expand and thrive, providing smoked sausages, sliced meat, and snacks nationwide. Seen at right, perhaps at the Chicago Stockyards, are Robert "Bob" Buddig (left) and his father, Carl, with a cow. Carl Buddig was also part owner of Michelberry's Log Cabin Restaurant at 2300 West Ninety-Fifth Street. Below, he is seen with a group of waitresses. Thirteen Buddig family members are buried at Mount Greenwood. (Both, courtesy of Thomas R. Buddig.)

Founded in 1912, E.G. Shinner & Co, Inc.—a wholesale and retail meat market chain—made national news in 1952, when it became the first firm sold to an employees' pension fund; about 10 percent of the employees were women. Previously, in 1943, he had established a non-contributory sharing plan for his employees. Shinner's innovative business concept was a meat market stocked with good, commercial-grade meats for working families who could not afford choice meat. The 33 outlets were in the industrial areas of Detroit, Flint, Pontiac, Decatur, Moline, Milwaukee, Beloit, Clinton, Davenport, Joliet, Harvey, and Blue Island. He was married to Emma Plato in 1912. Sadly, the couple's only child, Thomas, died of scarlet fever in 1930. (Both, courtesy of Pat Sparling.)

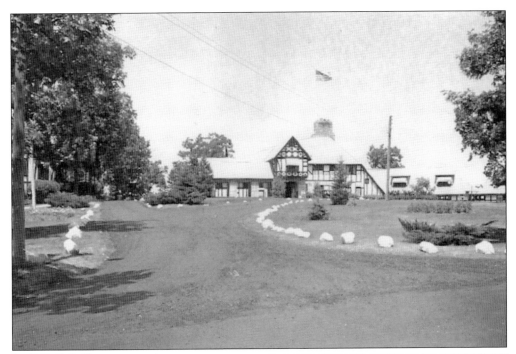

In 1921, E.G Shinner served as developer and founder of the popular Nippersink Hotel and Country Club on Lake Tombeau—a summer and golf resort near Genoa City, Wisconsin. The great lodge, the adjoining dining room—which accommodated several hundred people—and 100 cottages were built in an English style, with adjoining children's playgrounds. With square dances, movies, entertainment, and programs (right), it was a popular resort. Property for private homes was also sold. As a philanthropist, author, banker, builder, and millionaire, he founded the Shinner Political Economy Research Foundation to allow students and educators to gain "an understanding of the forces and factors that tend to produce higher standards of living." (Both, courtesy of Pat Sparling.)

Elmer Washburn Coffey and his wife, Laura Nickerson, met while singing at the Blue Island Methodist Church. Laura taught school, and Elmer was drafted in 1918, where he said that he won World War I by shoveling snow at the Great Lakes Naval Base. As an electrical engineer and graduate from the University of Illinois, he worked for R.R. Donnelly & Son, W.F. Hall Printing, and H.P. Smith Paper, and he retired as the plant engineer for the St. Regis Paper Company. He had a full workshop where he built furniture and inventive toys—such as an electric car made from a tricycle—and worked on his cars. Laura volunteered many hours at their church, and she often played the piano while Elmer played the violin, mandolin, or cornet. He was granted US Patent No. 2504251 for his "drafting-scale guard" for triangular rulers. (Both, courtesy of MGCA.)

On Thomas T. Bringley's marker is part of a line from Homer's epic poem *The Odyssey*: "I am looking for Odysseus, known for his great heart." Tom, almost 29 years old, had just received his doctorate in mathematics, but he loved the arts and classic literature. When ill, he would say, "Read me Shakespeare or Homer." After his passing, New York University held a conference in his honor. (Courtesy of Maureen Bringley.)

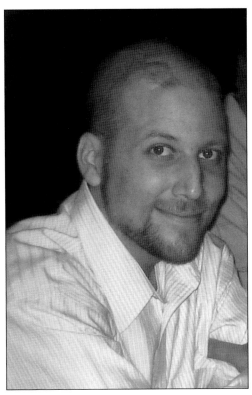

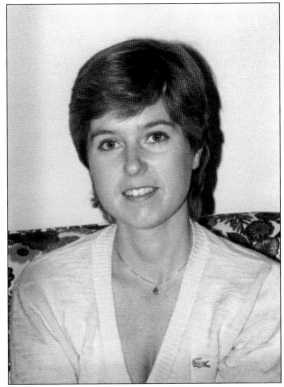

Jean Klenk was the oldest daughter of Joan and Paul "Ted" Klenk Jr. Educated at Monmouth College, she had a master's degree in education from Chicago State University and loved teaching high school in Oak Ridge, Wisconsin. She passed away at age 31. She is fondly remembered for her warm smile and earnest manner. (Courtesy of Klenk family.)

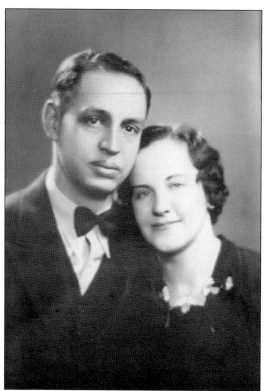

Anthony Zupancic, born in 1904, attended the Minnesota State Academy for the Deaf in Faribault with his wife, Edna Frank, who was also deaf. They lived in the Mount Greenwood community, where he worked as a tailor. Edna was described as very stylish and having beautiful clothing and jewelry. They traveled extensively. (Courtesy of Ann Marie Vlainkh.)

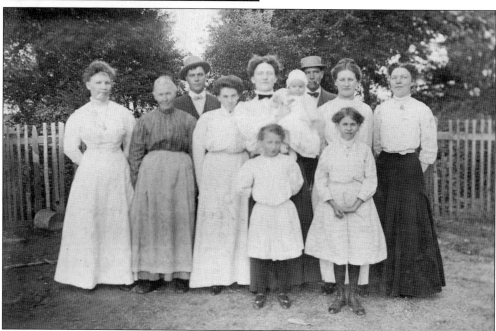

The Graefen family is seen here in about 1912. The husband of Joanna—the older woman—died in 1889 after a fall from a horse and buggy, leaving her with six children, including a one-year-old. Previously, in 1884, four of their children had died of diphtheria within 12 days of one another. Her husband was one of the earliest burials at Mount Greenwood. (Courtesy of Linda Jensen.)

Lula, age seven, is seen at right with her sister Anna Nagel, age 18, in 1908. Their mother died of tuberculosis that year, following their father's death from the same disease. Lula was sent to an orphanage in Lincoln, Illinois, for 10 years and returned to Chicago when she was 17. Anna married John Shug when she was 23, but she also died of tuberculosis at 25. Anna, her brother John (who was a railroad engineer), and their mother, Catherine, are all buried in unmarked graves. Lula Nagel married Garfield Anderson, seen below, who worked for the Pullman Company for a few years. In the 1930s, Garfield became a Chicago fireman with Engine Co. No. 75 at the 120th State Street Firehouse. Garfield's mother, Christine Anderson—who died of diabetes—is also buried at Mount Greenwood. (Both, courtesy of Robin Anderson Scheldberg and Karen McIntyre Novak.)

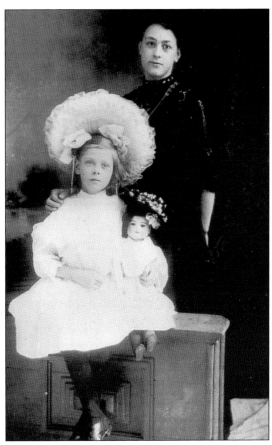

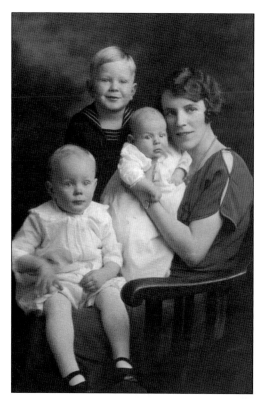

Seen at left in 1924 are Zonia Coffin Clemens and three of her sons (left to right), William D., born in 1923; Jack R., born in 1921; and baby Donald F., born in 1924. She was married to Jack F. (below), who served in the 1st Illinois Cavalry in World War I. Little William Clemens died of pneumonia at age five. A fourth son, Thomas, is also buried here. (Both, courtesy of Barb Marzillo.)

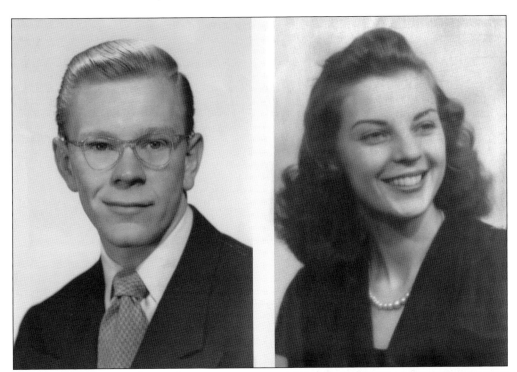

Pat and Jack Clemens, above, who attended Morgan Park High School and Clissold Grade School, were married for 55 years. Pat worked at the Walker Branch Public Library and the international headquarters of Rotary International (founded by local resident Paul Harris) in Evanston, Illinois. Jack, a mechanical engineer, worked on the development of B-52 plane engines, as well as other projects. He died in 2014 at the age of 93. In 1972, Minnie Clemens, at right, was 100 years old. Her husband, Benjamin, who lived to be 94, was a barber and repairman for the Santa Fe Railroad. They had more than 50 children, grandchildren, and great-grandchildren when she passed away. (Both, courtesy of Barb Marzillo.)

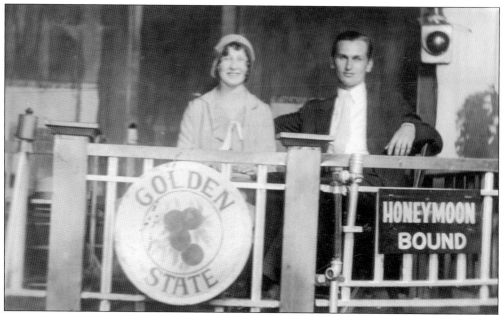

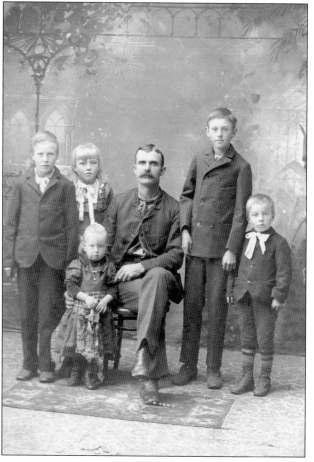

Lena, who was from St. Louis, Missouri, married William Schroeder in 1896. Unfortunately, Lena died in childbirth in 1909, and their five surviving children were sent to an orphanage. The photograph at left shows, from left to right, Elmer, Lena, Lillian, William, William Jr., and Raymond in about 1911. Family lore says that William's second wife, Tosco—a strong German woman—rented a buggy to bring the children back from Iowa. William Jr. married Ruth Stevenson and, for seven generations, the family has lived in the Mount Greenwood neighborhood, on Homan Avenue in a home built by Edna and Harry Stephenson. William Sr. and both of his wives are buried in Mount Greenwood. (Both, courtesy of Margaret Schroeder.)

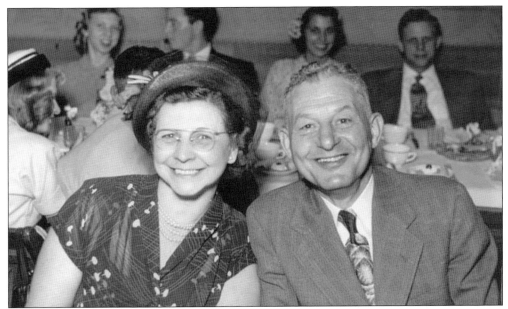

Mabel "Mae" Eenigenburg married Louis Bethig, a World War I veteran. Louis had the first Sinclair service station in Roseland, at 111th Street and Perry Avenue. Both were very involved in the Bethany Reformed Church's World War II efforts and were air raid wardens, making sure that no lights were visible in the neighborhood they patrolled. Louis passed away one month after their 30th wedding anniversary celebration. (Courtesy of Jill and Robert Eenigenburg.)

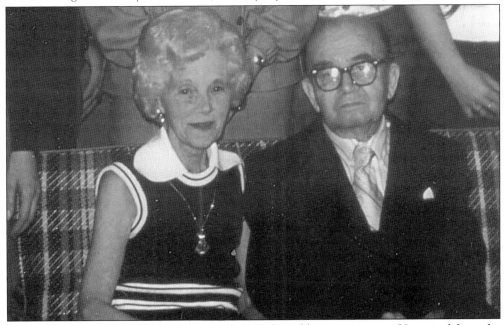

Florence and Roy Holm are seen here at their 50th wedding anniversary. He retired from the Grand Trunk Railroad Company and she had worked for the *Markham Bulletin*, which was owned by her nephew. They moved "out to the country" to Markham in the early 1940s, where many family gatherings were held. Roy's gardening skills were well known. There are many Holms buried at Mount Greenwood. (Courtesy of Joyce Beedie.)

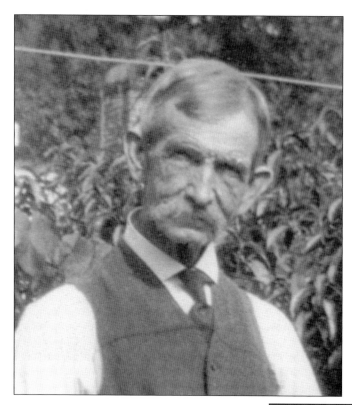

Webster Zeigler was the youngest son of Anna Katharine Berner and Peter Zeigler (left). They lived in Dubuque, Iowa, when he was young. Webster's wife, Blanche (below), was born and raised in Manitowoc, Wisconsin. They met at a church camp and were married in 1920. Blanche, who went to college in Appleton, Wisconsin, taught typing and shorthand and later worked for Sherwin Williams Paint Company as a clerk. She was a talented seamstress and raised African violets. Webster worked at the Calumet Shops of the Pullman Car Company as an accounting clerk. They had four children and nine grandchildren. (Both, courtesy of Patty Robinson.)

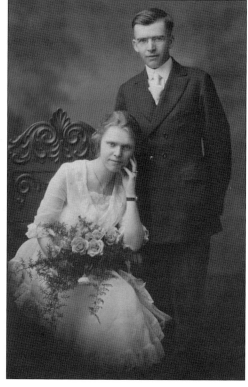

Dr. Charles Dryer Rich is a story of lost opportunity. A fascinating and well-written man, he and his baby son contracted tuberculosis from a patient in 1897, when he was 31. He was a student of Dr. J.L. Kellogg at the Chicago Homoeopathic Medical College. (Courtesy of JoAnne Bowie.)

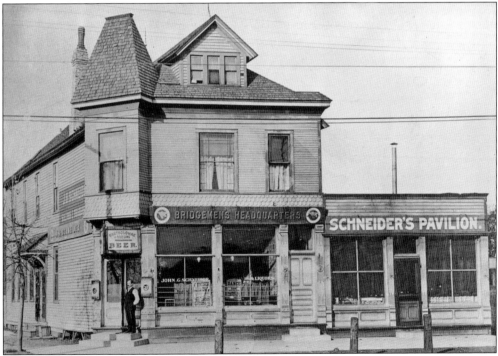

John and Hulda Zander Schneider were proprietors of the Washington Heights Schneider Tavern and Pavilion, at 104th Street and Vincennes Avenue. Hulda was born on a farm at Seventy-Ninth Street and Western Avenue. The sign for Bridgemen's Headquarters refers to the men who worked at Chicago Bridge and Iron, just to the north on Vincennes Avenue. (Courtesy of RHS.)

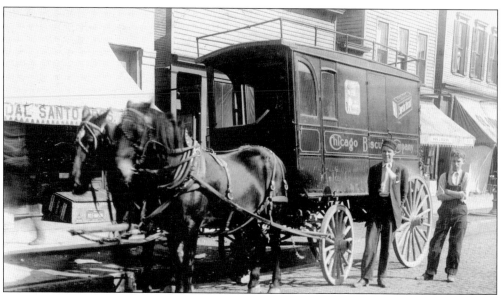

DeYoung Distributors still exists as a fourth-generation business. Ralph G. DeYoung, pictured above at left in 1909 with his brother James (right), used a horse-drawn wagon in his work as an independent cookie and candy distributor for the Chicago Biscuit Company, the Sunshine Biscuit Company, and others. He took over the business in 1908, at age 14, when his father—who had founded the business—died. Pictured below at the Sinclair gas service station at 111th Place and Perry Avenue—across from the old Roseland Community Hospital—are, from left to right, Julius "Slim" Goenenwein, Ralph DeYoung, and Louis Bethig. Ralph's 1915 Autocar, painted black and labeled Johnston Cookies and Crackers, operated until the 1950s. It had a hand crank and hard rubber tires that never needed replacement. (Both, courtesy of Merritt Bethig.)

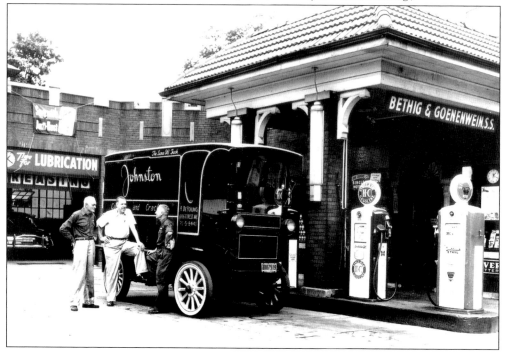

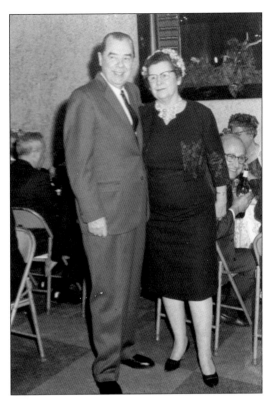

Ralph G. DeYoung, known as "the cookie man," married Louise Eenigenburg in 1918. She was known for her kind and loving personality, piano playing, beautiful garden, and sense of style. Fond memories exist of the parties, picnics, and family gatherings that she hosted. Many family photographs exist of those gatherings. Raymond Philip DeYoung was the youngest son of Ralph and Louise. Sadly, he died in 1938, near age 12, of a brain tumor while attending the Van Vlissingen School and Bethany Reformed Sunday School. He is remembered as unusually bright and having a very sunny disposition. (Both, courtesy of Carla DeYoung.)

Richard, the youngest son of Renze and Margaret VanderMey (née Kuipers), was born in Chicago. His parents emigrated from the Friesland province of the Netherlands in 1882. Jennie Ton was the oldest of two daughters born to Nellie Ton (née Tanis) and Cornelius H. Ton. They married in January 1915, and lived on the family farm near Seventy-Ninth and State Streets on the south side of Chicago. Richard first worked as a truck farmer with other family members, growing vegetables and taking them by truck into the city for sale. Later, he was a co-owner of the Great Southern Laundry, where he continued to work with family members for many years. Richard and Jennie eventually moved to South Holland. (Both, courtesy of Patty Robinson.)

Most of this book has been about families—how they worked to support themselves, lived through adversity, and gave back to their communities. Extended families, like the Rexford-Massey-Clarke-Rudds in the above photograph from the 1890s, are an excellent example of those who have contributed to this community. Mary Rudd is shown at right in about 1915. Her husband, Oscar, died during the Civil War, when she was only 24 years old and their young son, Willis, was only four years old. Willis, with the support of his mother and her family, become a renowned horticulturist and landscape architect. Like so many children in this book, he may never have succeeded as he did without his family. (Both, courtesy of BIHS.)

DISCOVER THOUSANDS OF LOCAL HISTORY BOOKS FEATURING MILLIONS OF VINTAGE IMAGES

Arcadia Publishing, the leading local history publisher in the United States, is committed to making history accessible and meaningful through publishing books that celebrate and preserve the heritage of America's people and places.

Find more books like this at
www.arcadiapublishing.com

Search for your hometown history, your old stomping grounds, and even your favorite sports team.